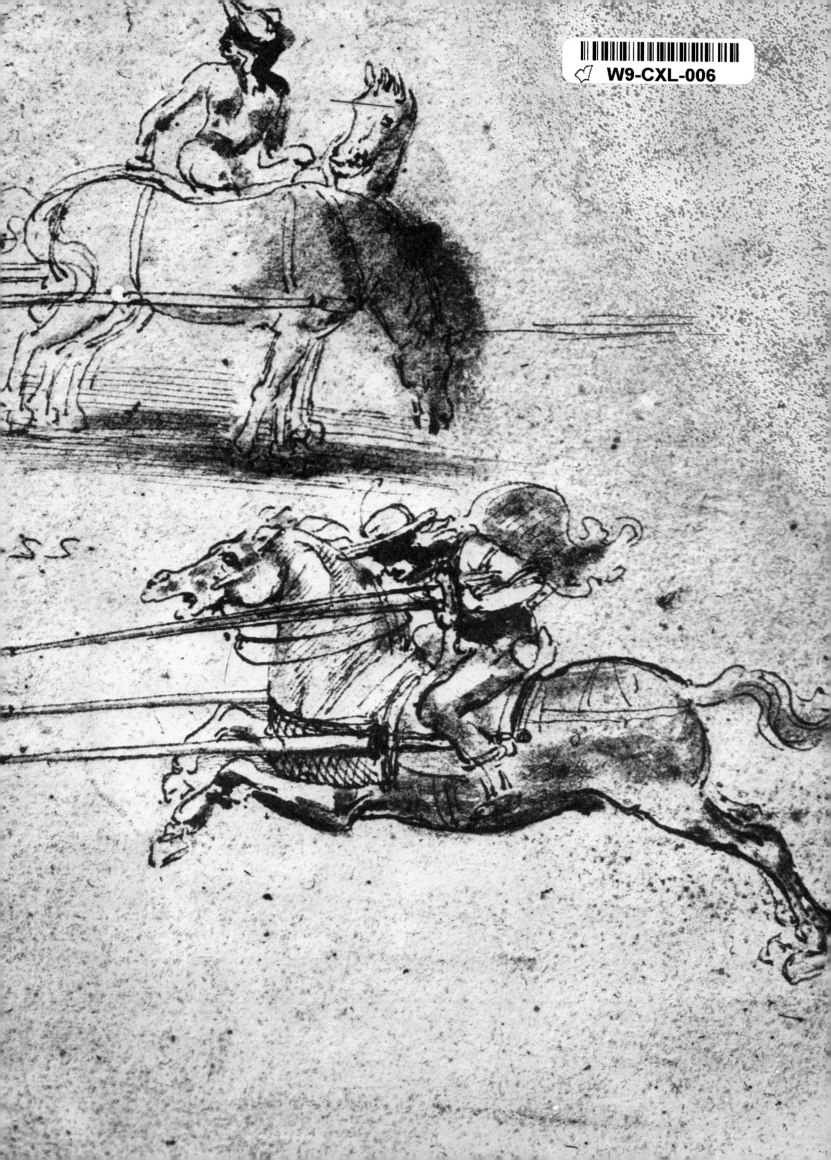

——THE ART OF——
LEONARDO DA VINCI

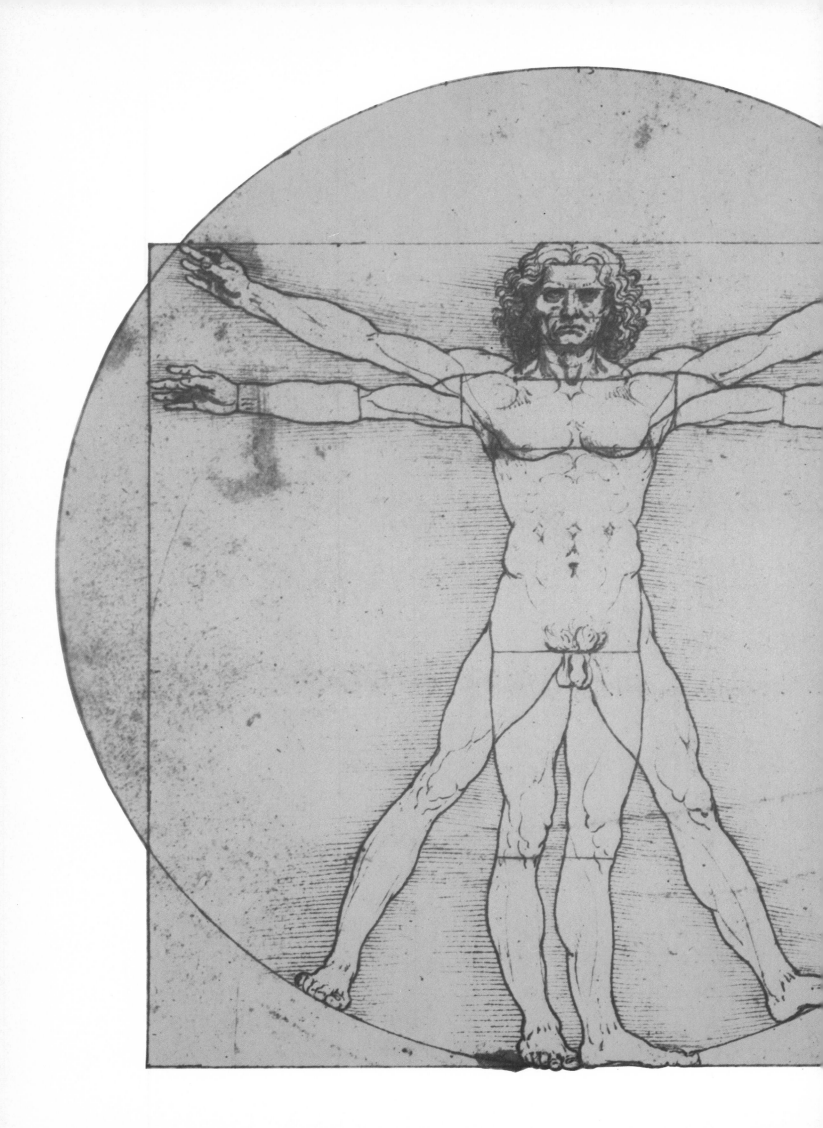

—THE ART OF—
LEONARDO DA VINCI
Douglas Mannering

EXCALIBUR BOOKS

NEW YORK

Designed by Groom and Pickerill

Copyright © 1981 The Hamlyn Publishing Group Limited
Reprinted 1983

First published in the USA in 1981
by Excalibur Books
Excalibur is a trademark of Simon & Schuster
Distributed by Bookthrift
New York, New York

ISBN 0-671-80669-6

Printed in Italy

Contents

Leonardo: an Introduction

'Sometimes the heavens endow a single individual with such beauty, grace and abilities that, whatever he does, he leaves all other men far behind, thus demonstrating that his genius is a gift of God and not an acquirement of human art.' This is Leonardo da Vinci as described by Giorgio Vasari in his *Lives of the Artists*, written over four hundred years ago to celebrate the painters, sculptors and architects of the Italian Renaissance, that outpouring of energy and genius that transformed European art between the 14th and 16th centuries. In his transports of enthusiasm, Vasari tended to be fulsome in praising his fellow-artists; but here he does more than merely praise. He suggests what many people have since felt about Leonardo – that he was unlike other men; that he was mysterious and exceptional as both an artist and a human being.

Since Vasari's time, Leonardo's fame has continued to grow, and he and the great painter-sculptor-poet Michelangelo have long been recognized as the supreme artists of their time. (We tend to think of them as about the same age, though Michelangelo was twenty-three years younger.) Since Leonardo's output was relatively small, this equivalence of stature is all the more significant. Every painting by him is an object of passionate attention, but one above all attracts an endless procession of reverent pilgrims. During opening hours at the Musée du Louvre in Paris there is always a crowd gathered around the *Mona Lisa*, perhaps the only painting in the world that is famous enough to be regularly caricatured in the press and used more or less facetiously in advertisements. When the French Government allowed it to be shown in the United States, the event was treated as a state occasion, involving the President, his wife and a whole host of notables in a ritual of cultural ecstasy.

Not only Leonardo's paintings and drawings, but even a few sheets of the voluminous notes made by him are eagerly sought by collectors, and are bought and sold for fabulous amounts. One reason for this is that Leonardo was much more than an artist, even if his paintings do remain his greatest single achievement. Since the publication of his notebooks revealed the full range of his interests – from anatomy and engineering to geology and mathematics – Leonardo has been held up to the world as the supreme example of the 'universal man', embodying an ideal to which men aspired during the Renaissance but have despaired of in our own age of specialization.

But although Leonardo's achievements were real enough, part of his fascination lies in his elusive personality, and in the paradoxes – and even the failures

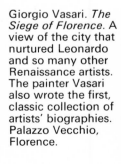

Giorgio Vasari. *The Siege of Florence*. A view of the city that nurtured Leonardo and so many other Renaissance artists. The painter Vasari also wrote the first, classic collection of artists' biographies. Palazzo Vecchio, Florence.

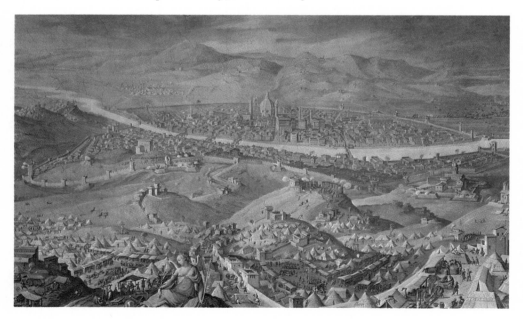

6

Head of a young woman. Galleria Nazionale, Parma.

– of his life. He was a child of the Renaissance, a time when it was possible to believe that 'man can do all things', yet a strange, melancholy thread runs through his paintings, drawings and writings. He was born in the city-state of Florence, at the very heart of the Renaissance, yet he chose to spend much of his life elsewhere, often in apparently less cultivated and stimulating environments. He was a charmer, a courtier, an organizer of fêtes and celebrations, but was also solitary and introspective. He created splendid ideal types in his paintings, yet his notebooks reveal that he was equally interested in the all too realistic aspects of decrepit crones, the deformed and the dead. He enjoyed surrounding himself with luxury and pampering his friends and servants, yet he was primarily a vegetarian, usually drank only water, and spent many of his nights dissecting corpses among the sights and smells of the charnel house. And, although he was so tender-hearted that he sometimes bought caged birds simply for the pleasure of releasing them, he also devoted much of his attention to military engineering and projected a whole series of horrific death-dealing instruments of war that another, equally sensitive man might have preferred not to contemplate.

These paradoxes and contradictions are not superficial, but extend into the heart of Leonardo's life-work. He is one of the greatest of Western artists, yet is known only by a handful of paintings which have escaped deliberate destruction or loss in obscure circumstances. Of the survivors, almost all are unfinished, damaged, decaying or have been altered by less competent hands. Leonardo was an experimentalist whose technical audacities often proved disastrous for his art, as well as being a perfectionist who was capable of putting off the completion of a task for years (which in practice sometimes meant for ever). The 'accidents' that befell his works were at least partly the outcome of such personal traits. Furthermore, the paintings themselves have always seemed

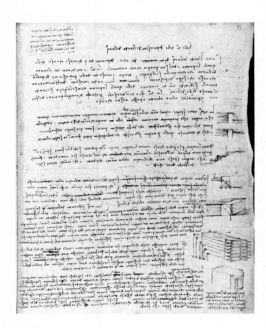

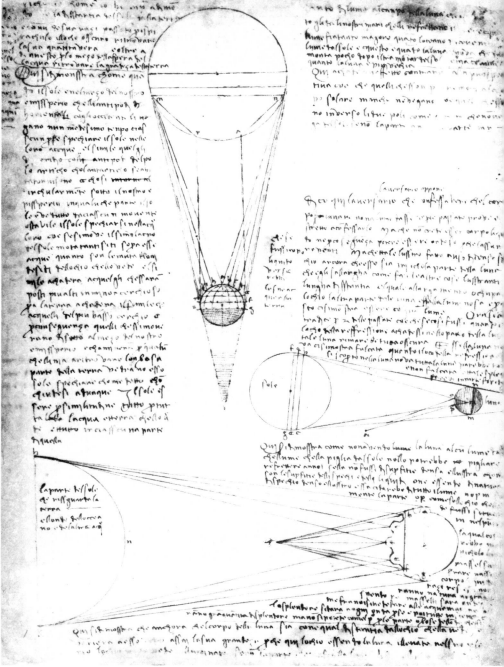

deeply mysterious, with their enigmatic, smiling women and haunting, misty landscapes that hint at some impalpable significance beyond the formal 'message' conveyed by the subject-matter. Even as material objects, the individual paintings often have strange and exotic histories that add to their fascination; one, for example, turned up on the shores of the Caspian Sea after several hundred years of obscurity, while others were bought, sold or stolen many times before coming to rest in collections as far apart as Washington, D.C. and Leningrad. Finally, there are the notebooks, filled with facts, observations, arguments and projects concerning the arts, sciences, technology, medicine, mathematics and so on. They were not published during Leonardo's lifetime, and not in any satisfactory fashion until recent times.

Leonardo's failure to publish, along with his difficulties in finishing, his technical mishaps and his self-defeating perfectionism, co-existed with the superlative qualities of his genius and his incredible capacity for hard work. Whether the negative as well as the positive aspects were essential ingredients of his creativity must remain a matter of opinion. Not only historians but also psychoanalysts, including the great Freud himself, have sought to understand Leonardo, but with strictly limited success. The apparent conflicts in his personality, crucial yet inexplicable, are not the least of the enigmas associated with this most enigmatic and fascinating of artists.

The 'Leicester Codex'. This 72-page notebook on the nature and movement of water was acquired by Thomas Coke, later Earl of Leicester, in 1717. It remained at the family seat, Holkham Hall in Norfolk, until it was sold at Christie's in 1980; Dr. Hammer, an American, bought it for £2·2 million.

Right: Studies of children. Musée Condé, Chantilly.

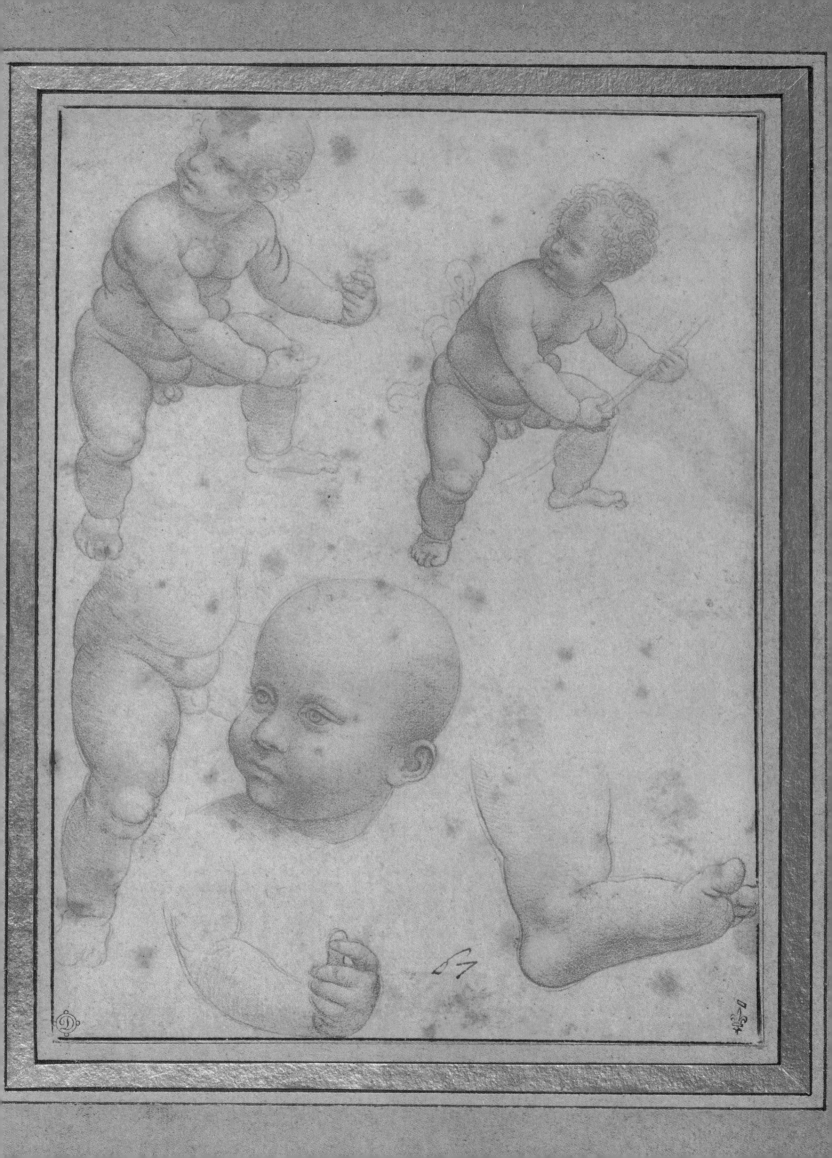

The Italian Renaissance

Benvenuto Cellini. *Gold Salt-cellar*. 1540–43. Cellini wrote the first autobiography by an artist. His famous salt-cellar was made for Leonardo's patron, Francis I of France. Kunsthistorisches Museum, Vienna.

Leonardo was born into a vigorous, purposeful, dynamic society – the Italian society during the great age of the Renaissance. The word Renaissance means 'rebirth', and the general movement it describes had indeed transformed both life and the arts in Italy, decisively breaking with the medieval outlook. Like most historical processes, the Renaissance had roots deep in the past and is therefore hard to date precisely; but it is clear that a good many Italians had developed a new attitude towards the world by the end of the 13th century, and during the 14th and 15th centuries Italy became the scene of a brilliant culture that was envied by even the greatest princes in other parts of Europe. They were eager to learn, and by the end of Leonardo's lifetime (1452–1519) Italian arts and graces had begun to spread across the Alps into northern Europe; he himself was to spend his final years as the most valuable cultural ornament in the possession of the King of France.

Most cultivated Italians believed they were literally witnessing a rebirth of ancient Greek and Roman civilization on their own soil. Superficially, Renaissance man appeared to be simply the most passionate of antiquarians, so besotted with the history, literature, philosophy, art and mythology of the ancient world that he despised the centuries since the fall of Rome and set himself to think, write and behave like a Greek philosopher or a Roman consul. Knowledge of the classics became the touchstone of learning (as it remained among the upper classes until quite recent times), and the Italian humanists, as Renaissance intellectuals and scholars were called, wrote not in their own language but in an elegant Latin modelled on the style of Roman masters such as Cicero.

This kind of revivalism, imitative and ultimately sterile, was an important aspect of the Renaissance, but behind it lay a whole range of attitudes that were genuinely new. The Greeks and Romans appealed to Renaissance man partly because of the value they seemed to place on life in this world, lived for its own sake; the medieval outlook, while not exactly hostile to 'the world', tended to regard it as a means rather than as an end, pleasure, knowledge and the fulfilment of man's secular potentialities being thought of as mere incidentals in the great drama of salvation. By contrast, these things were given pride of place in the classical life-style as Renaissance man understood it, and it was through classical models that he learned to understand and express his own desires. Despite its Greco-Roman trappings the Renaissance represented an essentially new statement of belief in the dignity and value of life and the limitless potentialities of human beings. Individual self-consciousness developed greatly, and with it the desire for self-improvement and the conviction that life could be understood and treated as an art; a manual such as Castiglione's *The Courtier* is as modern in spirit, and fundamentally the same in its objectives, as today's *How to Win Friends and Influence People*. Although the humanists wrote in Latin, other men expressed the new spirit more directly, in Italian. During the 16th century Machiavelli, for example, set himself to analyse the realities of political life instead of describing what it was supposed to be like; Benvenuto Cellini flourished his aggressive sense of identity, and the improved status of the artist, in his boastful, extravagant autobiography; and, outside Italy, men like the French essayist Montaigne and the English playwright Shakespeare added to the self-knowledge of humanity through feats of introspection and observation that would have been unthinkable in earlier times.

The new attitudes profoundly influenced the visual arts. The central medieval tradition, especially in painting, was concerned with arousing religious emotions rather than giving an accurate rendering of a scene. If it was effective in heightening the viewer's sense of awe, the medieval painter might make a saint impossibly taller than the other figures in a composition, or set the Virgin and Child against a flat, timeless background of brilliant gold paint – a setting

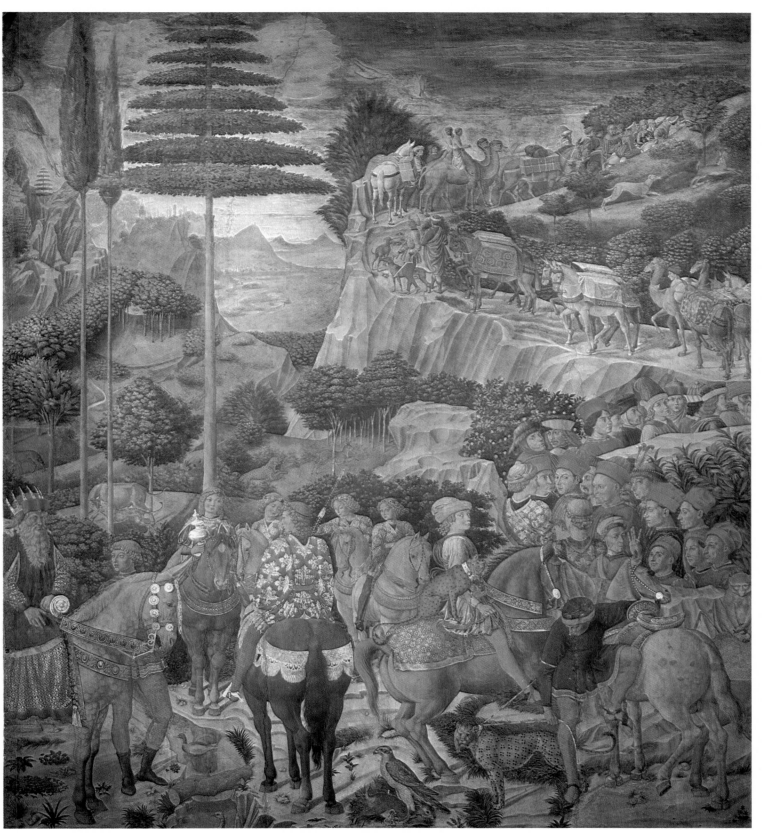

Benozzo Gozzoli. *Procession of the Magi*.
c. 1459. One of a cycle of wall paintings by
Gozzoli in which the Medici and their
courtiers are shown as the Wise Men and
their retinue. Palazzo Medici-Riccardi,
Florence.

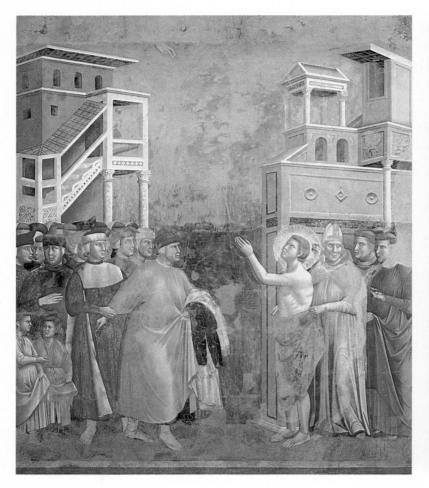

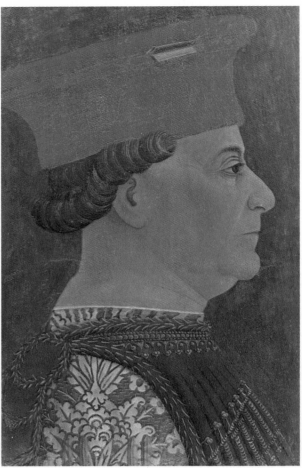

Giotto. *St. Francis Renouncing His Inheritance. c.* 1300. Giotto is generally considered the first great Renaissance painter. Upper church of San Francesco, Assisi.

Bonifacio Bembo. *Francesco Sforza.* A typical Renaissance portrait. Francesco was a successful mercenary commander who made himself Duke of Milan; his heirs were still in control of the state while Leonardo was working there. Pinacoteca di Brera, Milan.

in heaven or eternity rather than in the ordinary world of man.

By the late 13th century, Italian painters were beginning to strike out in a new direction. The greatest of these early Renaissance artists, Giotto, painted episodes from the lives of Jesus and St. Francis in which the remote, hieratic manner of medieval art was decisively replaced by scenes of intense human feeling and dramatic vigour. From this time onwards, painting and sculpture became increasingly concerned with physical reality – with accurately rendering the appearance of things. Eventually this included such subtleties as the way in which the fall of drapery indicates the presence of a solid body beneath it, and the way in which changes of size and tone tell us objects are nearer or further away; for this reason such subjects as anatomy and perspective became central preoccupations of many Renaissance artists. The world of man became the painter's real subject even when he painted a Madonna; the divine was now approached through the human – a change no doubt easier to accomplish where men believed that their God had manifested himself, and lived and died, as a man. As we shall see, Leonardo was one of the supreme masters of an art which exploited this duality, creating a painted universe that was at the same time utterly natural and suffused with an admittedly enigmatic spirituality. Despite eccentrics and exceptions, fidelity to nature became a driving impulse of Renaissance art, and the main principle of all Western art from the 16th to the early 20th century.

This, then, was the intellectual and artistic background of Leonardo's existence – the great humanizing, classicizing impulse of the Renaissance. Its power and confidence were derived from the vitality of the Italian cities which had achieved great wealth and sophistication while most of Europe was still living in the age of feudalism and chivalry. The chief source of this Italian wealth was the position of the peninsula on the route from the Mediterranean to northern Europe, which remained the principal artery of Western trade until the discovery of America and the sea routes to the East. The Italian cities exploited their situation both by trading in their own right and by developing credit and banking institutions far in advance of other nations. From the 14th century, Italian bankers were financing kings and emperors, and by Leonardo's time the Medici – the leading family in his native Florence – were employing agents all over Europe to look after the far-flung interests of their banking house.

Renaissance Italy gave credit to the rest of Europe just as she gave lessons in table manners, philosophy, politics and art; Europe admired and, eventually, imitated.

Yet the real political strength of Italy was negligible. In fact 'Italy' did not exist as a political unit, but was fragmented into a number of small states, each under the control of a more or less important city. Florence, Milan, Venice, Naples, and an indeterminate number of other Italian city-states maintained a jealous independence and formed kaleidoscopic patterns of alliance and enmity among themselves; the only semblance of unity (usually incomplete) occurred when an intruder appeared from beyond the Alps, whether bearing the fleur-de-lis standard of the French king or the eagles of the Holy Roman Emperor.

Forms of government varied widely among the Italian states. The Florence of Leonardo's youth was a mercantile republic, albeit one in which a single family, the Medici, exercised a near-hereditary supremacy. Venice too was both a republic and a great commercial power, but one with a fixed aristocratic constitution that made her internal politics less volatile but also less dynamic than that of Florence. Naples was a kingdom, Mantua a marquisate, Urbino a dukedom; but institutions could change over time. Renaissance realism encouraged the employment of mercenary commanders – *condottieri* – who on occasion managed to seize power for themselves. Successful tyrants awarded themselves various titles which, if their power and line endured, came to seem respectable; in this way Francesco Sforza made himself Duke of Milan, and by the time Leonardo settled there, the Sforzas had come to be regarded as the legitimate ruling house. Finally, there was the Papacy. The Pope was the spiritual head of Western Christendom, but he was also the absolute ruler of the city of Rome and of a large area stretching across central Italy. As an Italian sovereign he behaved much like the rest, scheming to increase his own power, attempting to destroy those he regarded as personal enemies, and taking part in

Domenico Ghirlandaio. *The Confirmation of the Rule.* An ecclesiastical scene in which the spectators are members of the Medici family and their followers. Santa Trinita, Florence.

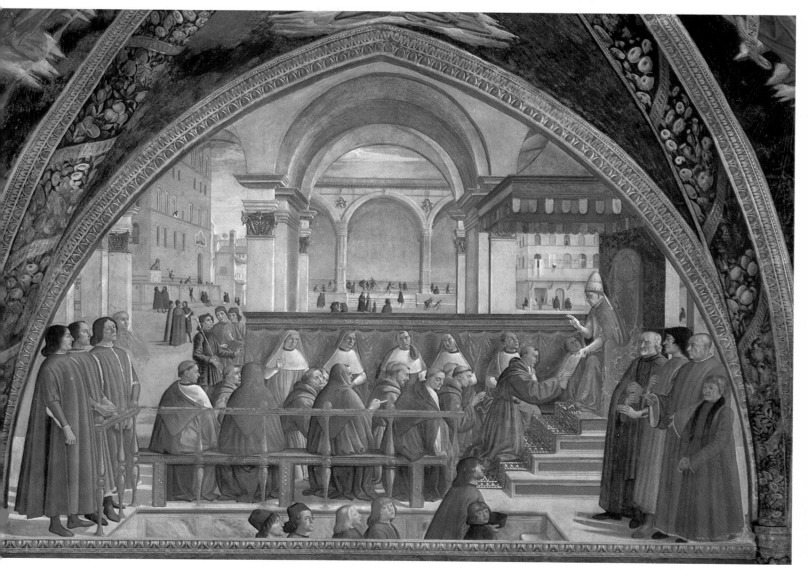

coalitions designed to prevent any single state from becoming too powerful. Renaissance Italy constituted a miniature universe of political manoeuvre in which the balance-of-power game was played more rationally, or at least more openly, than in other parts of Europe where lip-service continued to be paid to legitimacy, honour or Christian principles. Conscious — and conscienceless — statecraft was not publicly admired anywhere outside Italy, and although Machiavelli's *The Prince* was no more than an honest description of Renaissance politics, its dispassionate account of successful ruthlessness was to shock moralists for a century or more after its first publication in 1532.

The independence of the city-states and their diplomatic manoeuvrings had a direct influence on Leonardo's life. We shall find him moving from one centre to the next, and serving one master after another, with something of the amoral indifference shown by Machiavelli's ruthless men of power. (Machiavelli's 'hero' in *The Prince*, Cesare Borgia, was actually Leonardo's employer for a time.) The variety of courts and cities helped to give Italian art a healthy diversity, while their sheer number enlarged the practical opportunities and rewards available to the artist.

However great his eventual success, the artist began humbly enough, as a worker among other workers; and though by Leonardo's time the best artists were widely known by name, 'the artist' did not yet exist as an independent and freely 'creative' being in the modern sense. The painter and/or sculptor was trained and looked upon as essentially a craftsman — a man expected to know his business and work to order for his clients. In youth he served a formal apprenticeship to a master; after several years in the master's workshop he was admitted as a full member of the guild controlling his craft, and so was licensed to practise; and eventually, if he was lucky or talented enough, he might manage to set up his own workshop and in turn become a master directing a greater or

Fra Angelico.
Annunciation.
c. 1440. Dominican convent of San Marco, Florence.

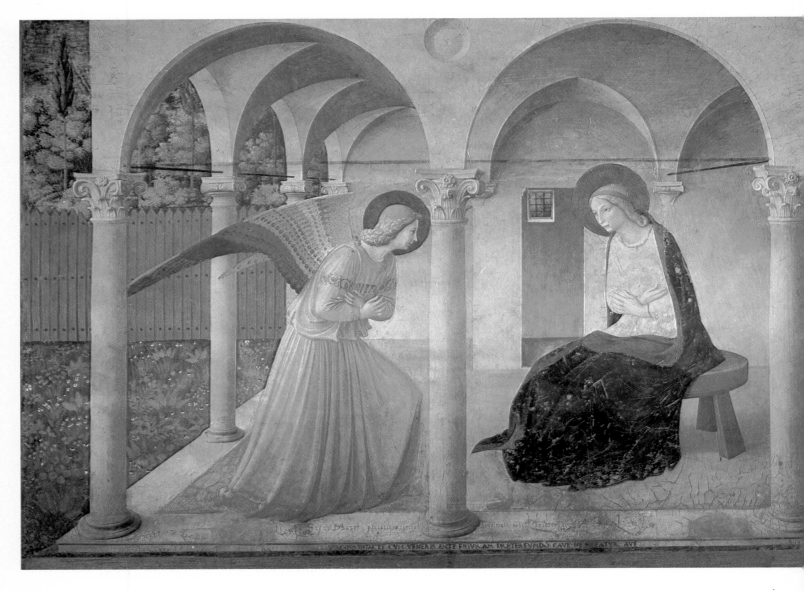

Masaccio. *The Trinity. c.* 1425/28. Masaccio brought a new solidity and realism to Renaissance painting. Santa Maria Novella, Florence.

smaller number of assistants and apprentices. A busy artist might entrust the whole or some part of a particular commission to his assistants, and in fact Leonardo's earliest known work as a painter is an angel that his master allowed him to put in the corner of a picture. The normal Renaissance workshop, like its medieval predecessor, was an essentially cooperative enterprise.

In the Middle Ages the Church had been the principal customer for art, and the overwhelming majority of images and objects created were directly religious in meaning and function. During the Renaissance, religious art remained as abundant as ever, although deeply influenced by the new humanizing spirit;

indeed, of Leonardo's fifteen surviving paintings, eleven have Christian subjects. But, thanks to Italian prosperity and the distinctive Renaissance outlook, princes and councils and merchants assumed a new importance as patrons, showing themselves willing to pay for a largely secular art intended to glorify themselves or their city. Fantasy, allegory and history were popular, but the greatest single new influence was classical mythology – the stories of Greek and Roman gods and heroes – which gave artists an inexhaustible fund of subjects derived from the very culture that Renaissance man worshipped and aspired to see re-born in his own land. Among other things, the cult of the classical meant the reappearance of the nude human body in art, accompanied by the kind of anatomical study and striving for naturalism that has already been mentioned. This too was both consistent with the human-centred outlook and directly inspired by what was known of ancient Greek sculpture. Classical mythology and history gave art a second 'language', with subjects, conventions and themes whose development could be studied in the works of one artistic generation after another, just as it is possible to study the treatment of Christian subjects such as Annunciations, Nativities, Adorations. The 'classical' was to have an extraordinarily long run in the history of art, surviving, in a finally vapid form, into the 19th century.

Portraiture also became one of the major concerns of European art during the Renaissance. Popes, princes and nobles, and even merchants, mercenaries and relatively obscure ladies and gentlemen, arranged to have their likenesses fixed for posterity – an effect, no doubt, of vainglory and the characteristic Renaissance obsession with fame and remembrance but one also owing much to the growing interest in the individual. Leonardo's portraits, culminating in the *Mona Lisa*, brought a new conviction of verisimilitude, and a new emotional force, to this branch of art.

The flowering of life, literature and the arts during the Renaissance was seen at its most splendid and extraordinary in Florence. This one small city probably produced more men of genius than any other spot on earth with the possible exception of ancient Athens. In the arts alone, Giotto, Fra Angelico, Masaccio, Botticelli, Brunelleschi, Ghiberti, Donatello, Verrocchio and many other painters, sculptors and architects appeared before Leonardo's time, and Michelangelo was only the greatest of those who came after him. Yet even in this company Leonardo is an exceptional being. He was very much a man of his time, touched at many points by the realities and influences described in this section, but he was also a man whose mind and art reached beyond his time, as an examination of his life will show.

Filippo Brunelleschi. *The Sacrifice of Isaac.* 1401. A bronze relief by the great architect; it was unsuccessful in competition with Ghiberti's (see right). Museo Nazionale del Bargello, Florence.

Lorenzo Ghiberti. *The Sacrifice of Isaac.* 1401. This bronze relief won Ghiberti the commission to make a set of bronze doors for the Baptistery, Florence; the result was so successful that he went on to make a second set, the famous 'Gates of Paradise'. Museo Nazionale del Bargello, Florence.

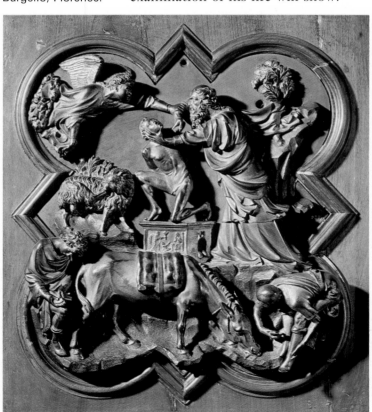

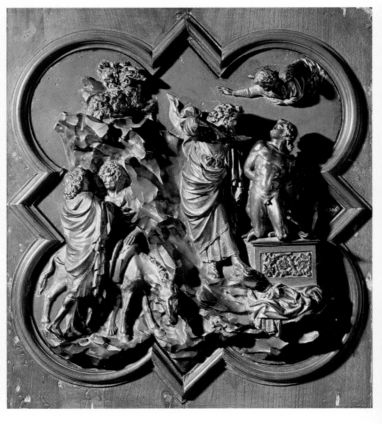

The Life and Works of Leonardo

Giorgio Vasari. *Lorenzo de' Medici.* A portrait of the statesman, patron and poet who dominated Florence for over twenty years. Galleria degli Uffizi, Florence.

Leonardo was born on 15 April 1452 at Anchiano, a village just outside the little town of Vinci; the name 'Leonardo da Vinci' simply means 'Leonardo of Vinci'. The town was only a few kilometres from Florence, and Leonardo's father, Ser Piero, built up a flourishing practice as a notary in the city itself, where he eventually acquired a house. So Leonardo almost certainly spent part of his childhood in Florence, which had already become the capital of European culture, with a population passionately addicted to art, money, ideas, wit, intrigue, luxury and learning.

Leonardo was illegitimate; his mother, Caterina, may well have been a peasant girl, for only Ser Piero is mentioned in the document recording Leonardo's birth. Although the notary married in the same year, he soon brought the boy into his household. Some writers have argued that Leonardo's personality was deeply influenced by the circumstances of his birth, but on the whole it seems unlikely. In Renaissance times illegitimacy was common and entailed little or nothing in the way of social disadvantage; half a century later another bastard, Cesare Borgia, the son of a pope, failed only narrowly in his bid to become permanently installed as a tyrant ruling much of central Italy. Furthermore, Leonardo may have benefited by growing up as an only child; Piero, four times married, had no legitimate offspring until Leonardo was a man in his twenties. In an age when sons had a material as well as an emotional value – their marriages brought in dowries and cemented family alliances – he probably enjoyed a secure and pampered boyhood.

More legends than facts have survived concerning Leonardo's childhood and early youth. According to one story, a peasant who owned a shield asked him to paint a device on it, and the boy – or perhaps he was now a young man – did so, using lizards, bats and similar creatures as models. The result was so lifelike that his father had a nasty shock when he came upon it unexpectedly. But Ser Piero reacted with a characteristic shrewdness; he gave the peasant a crudely painted substitute for his shield, and meanwhile took Leonardo's work into Florence and sold it for the handsome sum of a hundred ducats.

When and where the young Leonardo studied is not known, although there is a strong tradition that he worked under Andrea del Verrocchio while he was still a child. Verrocchio was the leading Florentine sculptor after the death of Donatello in 1466, and he ran a flourishing workshop in the city. The earliest documentary evidence of Leonardo's artistic activity dates from 1472, when he registered as a member of the painters' guild, the Company of St. Luke. He was twenty at the time, and if he had undergone a formal apprenticeship he must already have spent at least four years with Verrocchio. His association with the workshop lasted for another four years or more, so there can be little doubt that Verrocchio and his pupils – who included such later distinguished artists as Lorenzo di Credi and Perugino – exercised a deep influence on Leonardo.

Verrocchio's workshop must have been one of the liveliest, busiest places in Florence. The master and his pupils were not simply painters and sculptors, but craftsmen in marble, metal and wood who were prepared to take on virtually any lucrative commission they were offered; they designed and made armour, church bells, elaborate carved wedding chests, jewellery and even death masks. The concerns of the workshop, involving specific skills and definite plans and calculations, obviously appealed to Leonardo far more than the rarefied discussions of the intellectuals gathered round Lorenzo de' Medici. These Florentine humanists were not indifferent to painting and sculpture of a symbolic-allegorical type, but they set most store by a graceful Latin style and an elevated philosophy (neoplatonism) in which poetry, myth and symbol were valued more highly than everyday realities. Leonardo seems to have despised this kind of 'culture', which may be why he was never seriously taken up by the Medici. Although he might have studied and learned Latin at any time, he

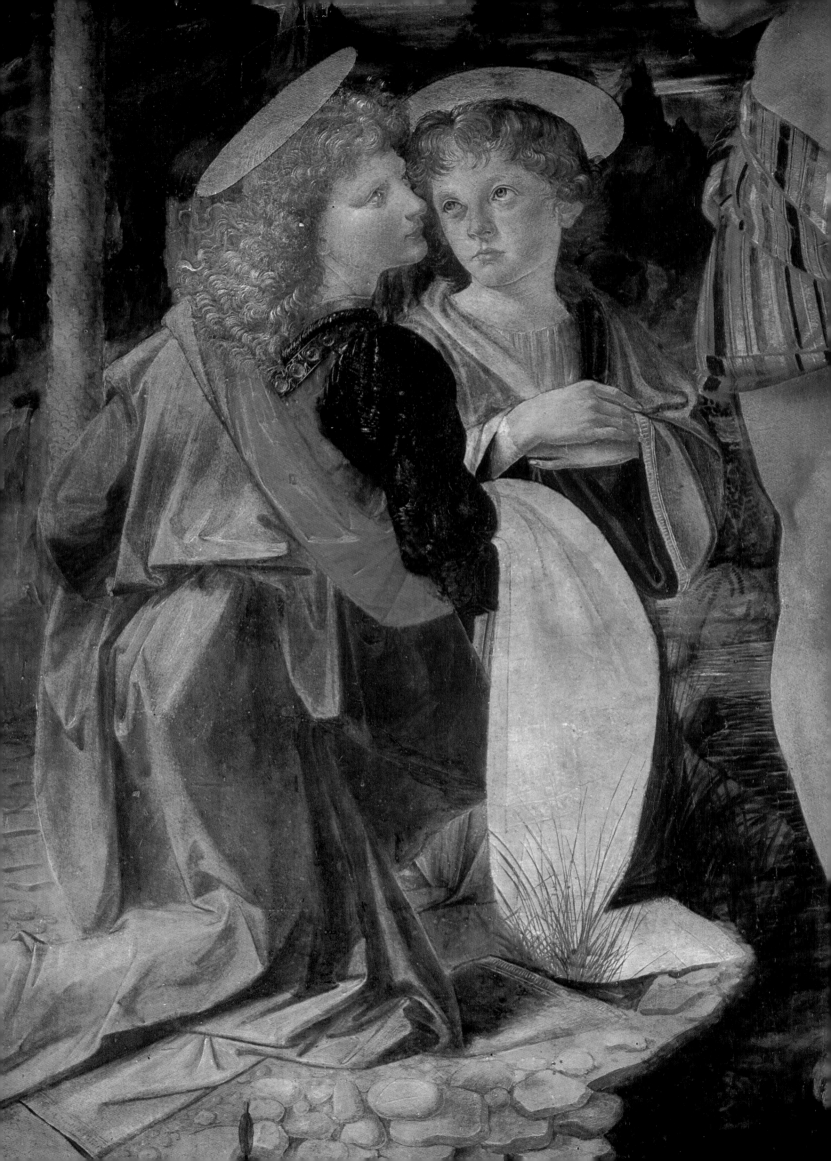

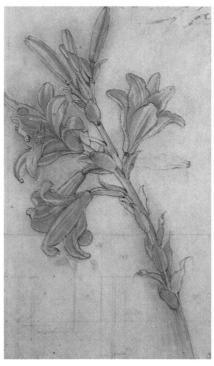

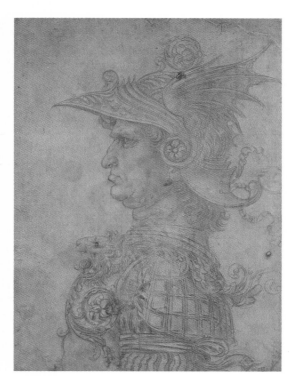

Left: Andrea del Verrocchio. Detail of angels from the *Baptism of Christ. c.* 1472. The angel on the left was almost certainly painted by Leonardo, working as Verrocchio's pupil or assistant. Galleria degli Uffizi, Florence.

Right: Drawing of a Lily. A very early drawing done with pen and ink and wash. It has been pricked for transfer (a method, described in the text, of transferring the drawing outline on to canvas as a painting guide), but there is no known painting by Leonardo with a plant depicted like this one. Royal Library, Windsor Castle.

Far right: Drawing of a Warrior. A highly-finished silverpoint drawing dating from the early 1470s and displaying the same youthful delight in elaborate ornament as the Uffizi *Annunciation*. It is probably a copy of Verrocchio's *Darius,* a bronze relief that has not survived. British Museum, London.

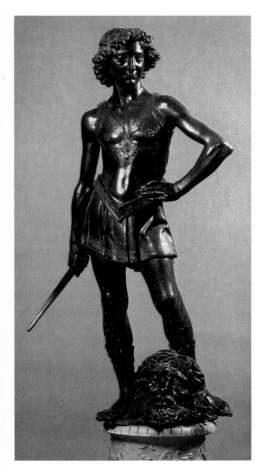

Above: Andrea del Verrocchio. *David. c.* 1476. A masterpiece in bronze by Leonardo's master. Museo Nazionale del Bargello, Florence.

clearly thought it was not worth bothering about until, in his forties, he felt that he had to read the works of Archimedes. The paradoxical result of this cultural gap was that, despite his profound knowledge of the arts, anatomy, physics, engineering and a dozen other subjects, Leonardo da Vinci was regarded by some of his contemporaries as 'unlettered' and, therefore, uneducated.

THE EARLIEST WORKS

Verrocchio is important in the history of art as a sculptor of genius. His famous *David* is an attractive, curly-haired but somewhat arch young man, posed like a big-game hunter with the head of Goliath at his feet; inevitably, though without any real justification, the boyish victor has been seen as a representation of the apprentice Leonardo. Verrocchio's finest work was a magnificent equestrian statue of the mercenary general Bartolommeo Colleoni, who becomes in the sculptor's vision a fearful epitome of will and brute strength. By comparison with his genius as a sculptor, Verrocchio was a mediocre painter – uninspired, but competent and workmanlike enough to play his part in meeting the contemporary demand for religious and mythological subjects. His *Baptism of Christ*, commissioned by the monks of San Sepolcro, is now remembered for the parts he did *not* paint. This rather ungainly work of conventional piety shows Jesus being baptized by St. John. In the left-hand corner are two blue-robed angels on their knees, looking appropriately soulful; one is a charming urchin of the type usual at the time, but the other – Leonardo's – is something new, with a sweet, mysterious, not-quite-human beauty such as occurs again and again in his later work. According to the life of Leonardo by Vasari, Verrocchio was so overwhelmed by the quality of this figure that he never painted again – actually a most improbable over-reaction on the part of a hard-working, down-to-earth professional artist. At least part of the landscape background in the picture must also be by Leonardo, for it already suggests the hazy, enchanted vistas of rock and water found in his mature work.

The *Baptism of Christ*, our first evidence of Leonardo's talent as a painter, belongs to roughly the same period as his earliest surviving drawing. On this he carefully recorded the subject and date, 'The Day of St. Mary of the Snows, 5 August 1473', writing backwards and right-to-left so that the words could only be read by holding the paper in front of a mirror. When he began to keep notebooks he covered thousands of sheets with this mirror-writing, perhaps from some instinct of concealment, perhaps only because – like many other left-handed people – he found writing backwards comfortable and natural. The drawing itself is remarkable, both as a piece of pure landscape (still a relatively rare occurrence in European art) and for the rapid, suggestive pen strokes which call to mind the swift, spontaneous touch of the Oriental master rather than the meticulous detail of a contemporary European. Here, at the beginning of

Left: Detail of background landscape from *The Annunciation*. 1472–3. As this demonstrates, even as a young man Leonardo was attracted to melting, mysterious landscapes. Galleria degli Uffizi, Florence.

Below: *The Annunciation*. 1472–3. Galleria degli Uffizi, Florence.

Right: Detail of the Archangel Gabriel from *The Annunciation*. 1472–3. Galleria degli Uffizi, Florence.

Far right: Detail of reading stand and plinth from *The Annunciation*. 1472–3. The simplest explanation for the inclusion of the grotesque stone plinth seems to be that it was a studio 'prop', which Leonardo painted with a young man's enjoyment of elaboration for its own sake. Galleria degli Uffizi, Florence.

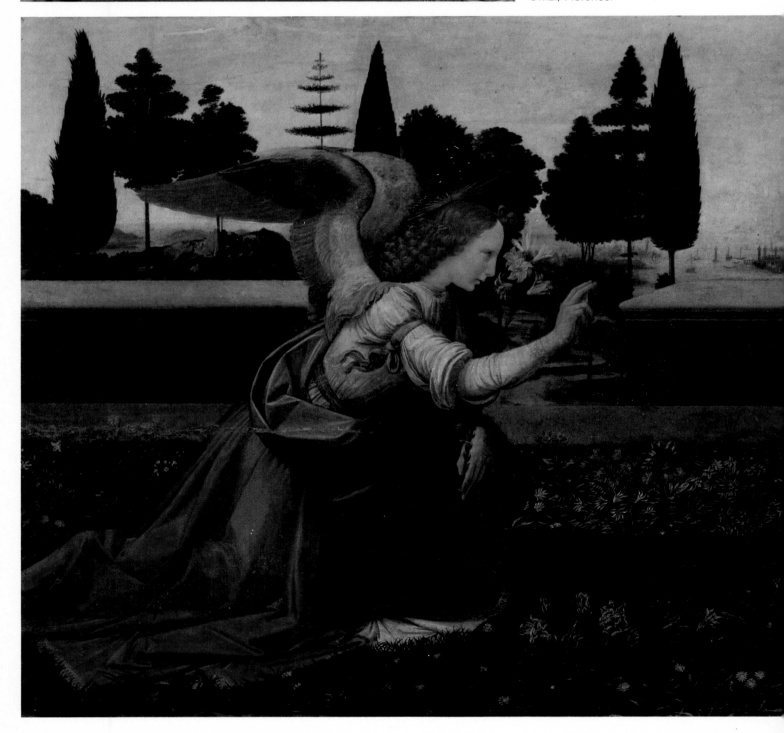

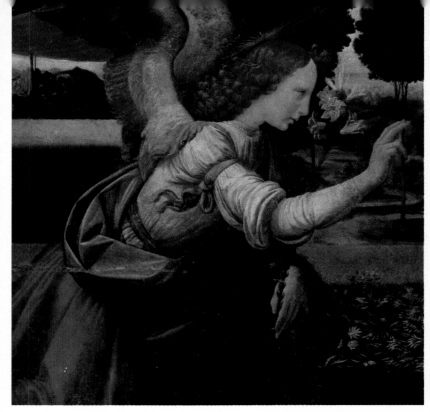

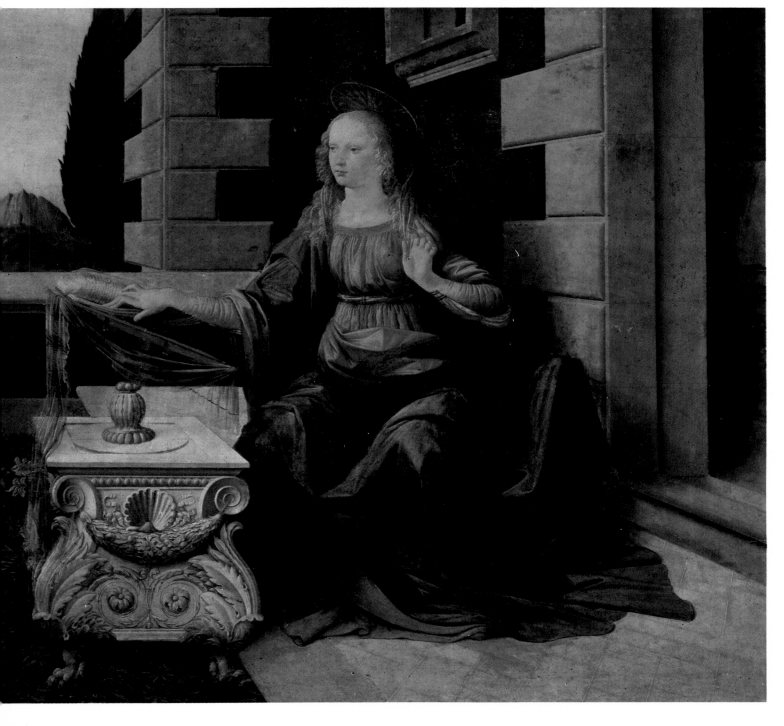

Right: *Landscape.* 1473. The earliest known drawing by Leonardo, done with pen and ink; it is curiously 'Oriental' in quality. Galleria degli Uffizi, Florence.

Right: *Madonna and Child.* 1470s. A painting often, but controversially, attributed to Leonardo; subsequent repainting has made it all the harder to be sure. Alte Pinakothek, Munich.

Leonardo's career, his vision of nature is already one in which a formidable power expresses itself through dynamic growth, movement and change. It was to become a characteristic preoccupation, and a most unusual one in an age that identified cosmic force with the human drama of a crucified Man-God. Leonardo's obsession with nature appears again and again in his notebooks – in studies of plants, rocks, cloud formations and, above all, water, culminating in cataclysmic visions of universal destruction by a new Flood.

Leonardo's works can only be described as accident prone; and the paintings he executed during his twenties are no exception. Every one was left unfinished, or has been damaged or badly repainted. By chance, the earliest is in the best condition. *The Annunciation* has been overpainted in places and is dark with the grime of centuries, but the painter's general intentions are clear. It is a young man's effort, aiming for a rather dull correctness of perspective and compositional effects (in spite of which the Virgin's right arm had gone badly wrong, coming from impossibly far back in the picture to rest on the near edge of a reading stand in the foreground). The Archangel Gabriel is announcing to Mary that she has been chosen to become the mother of Jesus; between the two figures, supporting the reading stand, is a large, hideously elaborate stone plinth which is given a curious prominence. The mystery and emotion associated with the Annunciation are absent; only the landscape background is more than conventionally eloquent.

The most problematic of Leonardo's paintings are three Madonnas dated between 1473 and 1480. Representations of the Virgin as a young mother, with her baby held lovingly in her arms or on her lap, have been enormously popular in Italy for centuries, so the three paintings in question may well have been adapted several times to suit current taste. At any rate they have all been heavily overpainted, and Leonardo's hand can only be recognized in a number of details or outlines that have also been found in his notebooks; such correspondences, identified by generations of zealous Leonardo scholars, are in fact the only hard evidence that the paintings are by him. (It remains possible, of course, that one or more of them originated as a contemporary copy of a lost Leonardo.) The most 'Leonardesque' of the three is the *Benois Madonna*, in which the Virgin is represented as a very young girl who takes an almost childish pleasure in her baby and in the flower she is holding up for him to see. But the history of these works, were it known, would probably prove more fascinating than the works themselves. In this respect the *Benois Madonna* is again the most interesting, turning up at Astrakan on the edge of the Caspian Sea in 1824, having survived for more than three centuries without any record having been made to prove that it had ever existed. It eventually passed into the hands of a Madame Benois, who sold it to the Hermitage Museum in St. Petersburg (now Leningrad) which still possesses it.

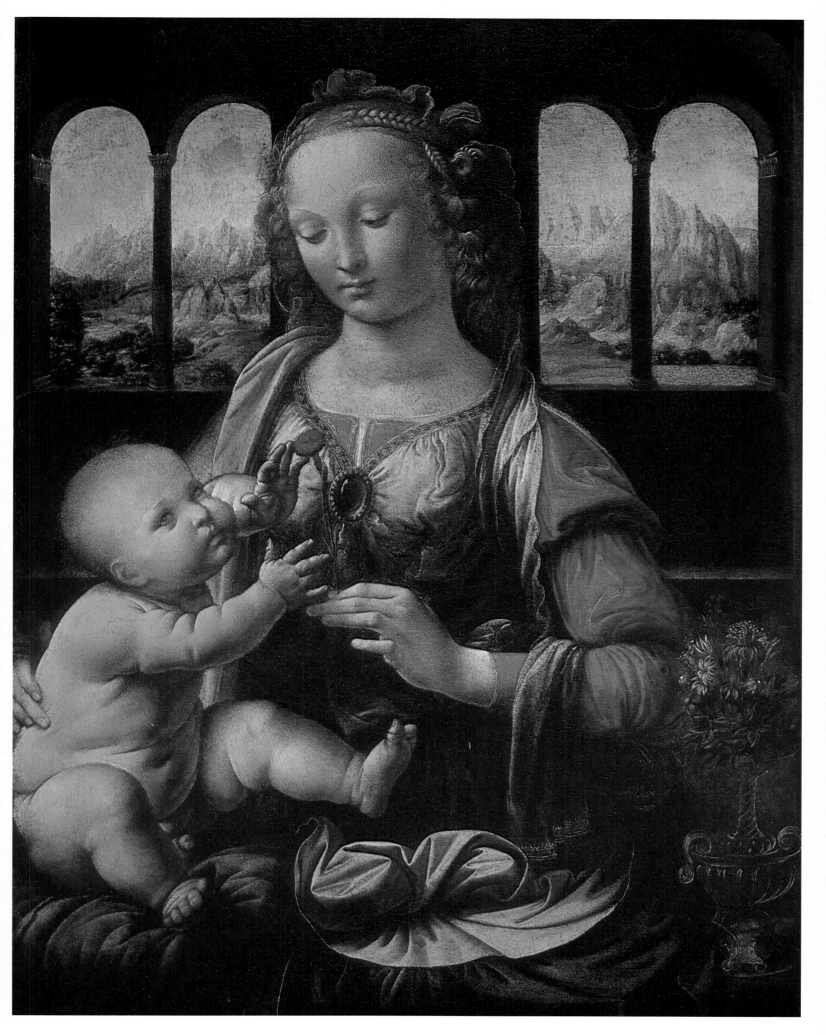

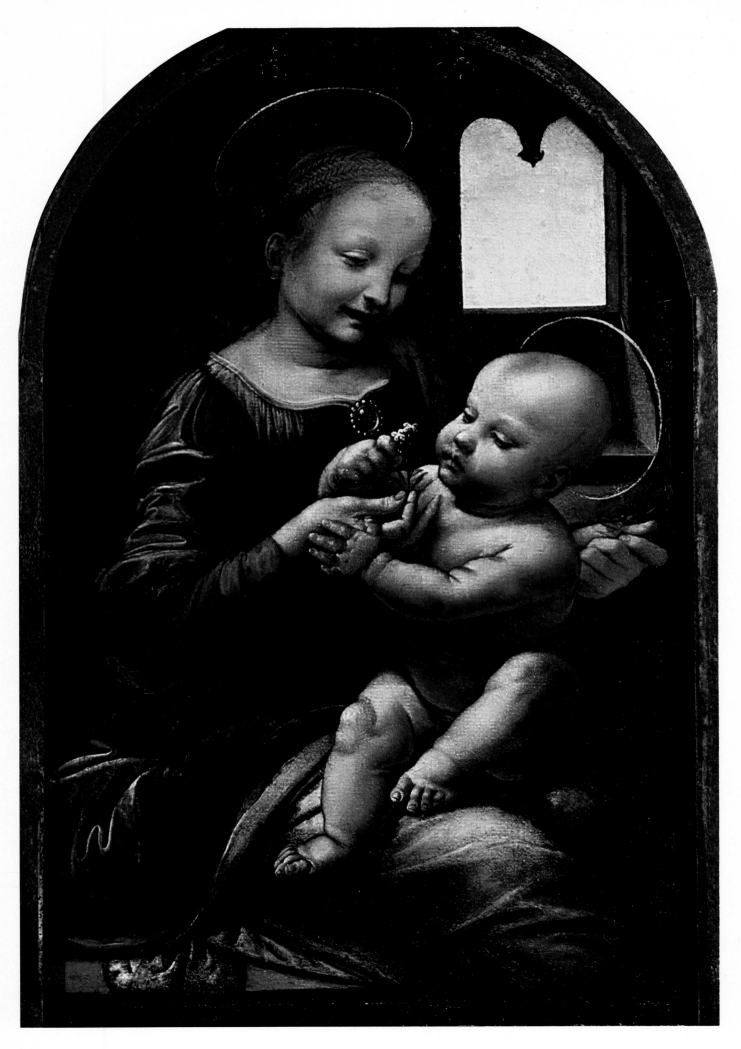

24

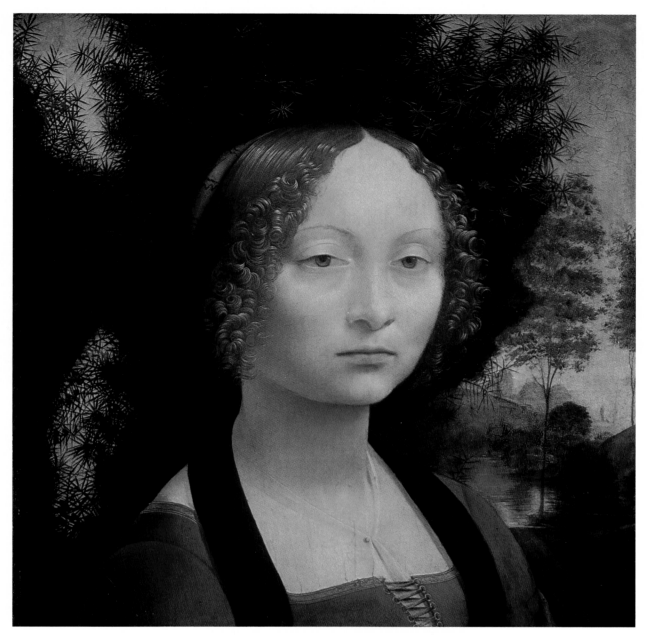

Leonardo's portrait of *Ginevra de' Benci* is probably the earliest of his surviving works that can be called a masterpiece. It too has a mysterious and interesting history since it first appeared in the early 18th century, when a Prince Liechtenstein became its owner; it stayed in the Liechtenstein Galleries in Vienna and Vaduz until 1967, when it was bought for $5 million by the National Gallery, Washington, D.C. The lovely colours and the fine modelling of the sitter's gravely enigmatic features give the picture its haunting quality, but the proportions jar for the very reason that the lower part of the work, including Ginevra's hands, has evidently been cut off. There is a juniper tree immediately behind her because 'juniper' is – at a couple of linguistic removes – *ginevro*, a masculine version of her name (gin, which is flavoured with juniper berries, owes its name to the same connection). Renaissance artists took great delight in such visual word-games.

A good deal is known about Ginevra de' Benci, a cultivated Florentine lady who married a prominent citizen, then became involved in an unhappy love affair with the Venetian ambassador, and afterwards took refuge in piety and seclusion. It is tempting to suppose that Leonardo is portraying a woman of sorrows, but on stylistic grounds the painting has generally been dated earlier, to about 1474, the year in which she married.

Fine as the *Ginevra* is, it does not have the immediately identifiable Leonardo quality of paintings done a few years later, such as the *Adoration of the Magi*. Nevertheless, a first sight of the *Adoration* comes as a shock. Instead of a finished painting, we are faced with something more like a very large, confusingly crowded drawing on a coloured background that has changed with time into

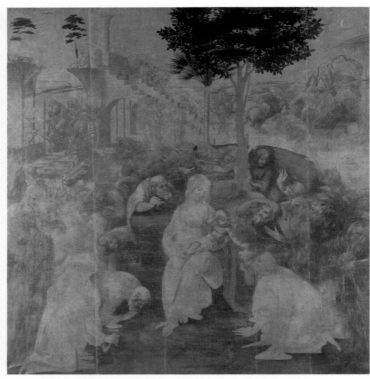

an unappetizing pinkish-yellow. Leonardo was commissioned to paint an *Adoration* for the monastery of San Donato a Scopeto in March 1481, and during the summer the monks supplied him with wood, money for colours and even a barrel of wine. But after the 28th September they paid nothing more, and it seems reasonable to suppose that Leonardo stopped work on the project at about that time. The preliminary drawings he made (and those now in existence can be no more than a fraction of the original number) indicate the care he lavished on the perspective and other details. The painting in its present state represents several months' effort, and Leonardo may have given up because he despaired of getting it done within the two-and-a-half years stipulated by his contract with the monks. Finishing the sixty-odd figures in this ambitious picture might have become the task of a lifetime for such an obsessive perfectionist as Leonardo. Here, as on other occasions, he seems to have behaved quite unlike the average, sober businessman-artist of his time, aiming instead to satisfy himself rather than his employers, and readily abandoning work when he had exhausted its possibilities or when the only alternative was to finish it by doing less than he was capable of. His patrons complained and threatened, but the uniqueness of his genius was so apparent that Leonardo's vagaries were generally indulged. The monks of San Donato, for example, seem to have gone on hoping that he would complete the *Adoration* even after he had left Florence, for it was only years later that they brought themselves to order an *Adoration* from Leonardo's younger contemporary Filippino Lippi, who dutifully produced a conventional but completed painting.

Even as it stands, the *Adoration of the Magi* is a remarkable conception. In this traditional episode the Magi, or 'Wise Men', bring gold, frankincense and myrrh to the new-born Christ-child who lies among friendly animals, watched over by his mother, in the manger of a stable. In most paintings the event is enclosed, solemn, ceremonial. Leonardo brings it out of the stable and into the world, surrounding the Virgin and Child and the worshipping Magi with a frenzied multitude of onlookers who seem appalled rather than enlightened by the magnitude of the event they are witnessing. Leonardo's mastery of *chiaroscuro* – effects of light and shadow, employed to give a convincing illusion of three-dimensional existence – is seen here for the first time and was to remain a distinguishing feature of his art, as were the lovely flowing lines with which the Virgin in particular is rendered. Although a ghostly figure, she, along with her child, forms a calm, serene centre around which the human storm rages. In the background a number of indistinct events are taking place, including some kind of struggle between opposing horsemen, perhaps intended to signify that ordinary life and its preoccupations are going on outside the turbulent area of onlookers. The setting is impressive – a ruined palace courtyard with a

diagonal line of stairs going off into empty space, linked to the central event by the tall tree which anchors the whole composition. The solitary figures at each side 'frame' the scene; the one on the right, looking out pensively beyond the viewer, is said to be a self-portrait of Leonardo.

The *Adoration* probably has a greater appeal for us than it did for Leonardo's contemporaries, though there is no doubt that another giant of the High Renaissance, Raphael of Urbino, deeply admired and learned from it. Modern taste often prefers the spontaneity shown in a preliminary drawing to the more conscious art of a finished painting, and in this case it is difficult to imagine how Leonardo could have taken his work any further. It is precisely the pale, ghostly nature of the central figures that enables the crowd to be clearly seen and felt; painting and 'finishing' them would have spoiled the contrast and replaced it with confusion. The *Adoration* is, arguably, most satisfactory in its present state.

The *St. Jerome* is similar in style and probably dates from about the same period. It is even similar in that it is unfinished and now almost monochrome; the combination of varnish and ground colours has become orange and brown in the centuries since it was painted. At the beginning of the 19th century the picture was literally dismembered, and only reassembled thanks to the efforts of Cardinal Joseph Fesch, whose other historical distinction was having been Napoleon Bonaparte's uncle. After Fesch's death the painting passed into the Vatican Museum.

The life and works of St. Jerome deeply influenced the development of the Catholic Church, and for centuries he has been a favourite subject for artists. He was a scholar whose translation of the Hebrew and Greek testaments into Latin became the sole accepted text – the Vulgate – for all Catholic Christians. As such he is conventionally shown at work in his study, wearing his cardinal's red hat and surrounded by books. But the scholar also spent years in the East as an ascetic, and this other aspect of his personality is differently mirrored in art. Unlike the comfortable book-surrounded cardinal, the ascetic Jerome is a near-naked old hermit who inhabits a cave in the desert; his chest is covered with self-inflicted bruises that witness his struggles against carnal temptations. The only point of contact between the two types of representation is the lion, the saint's emblematic beast, which is always shown with him, whether in the study or the desert. Jerome, like Androcles in a still earlier legend, is said to have won the lion's devotion by removing a thorn from its paw. In Leonardo's painting the lion is roaring as though in sympathy with his suffering master. Jerome is a very old man – much older, or at least much nearer to death, than other artists

Perspective study for *The Adoration of the Magi*. 1481. Galleria degli Uffizi, Florence.

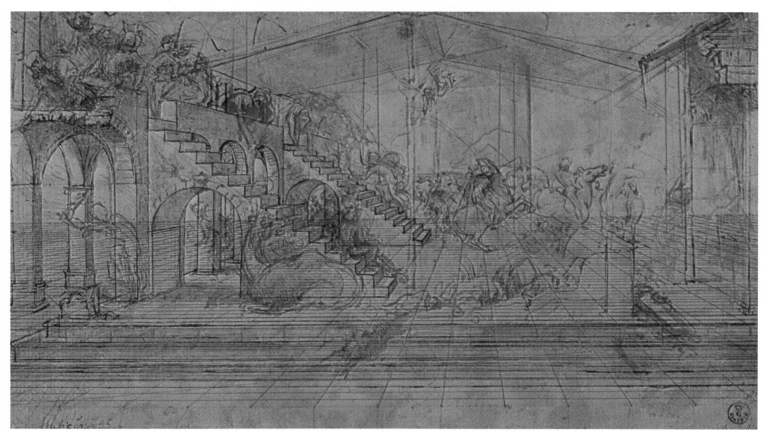

have imagined him. His emaciation gives Leonardo an opportunity to display the anatomical knowledge for which he laboured so hard (as we know from later evidence), dissecting in hospitals and painstakingly recording his findings in his notes and sketches. But the prominent bones and straining muscles and sinews are not represented here for their own sakes. Age and emaciation impart a terrible pathos to this wilful self-punishment, and it may not be too fanciful to interpret the lion's roar as one of protest against an old man's self-destruction. The composition of Jerome's figure is superb and unforgettable; from the hollow, vulnerable body the eye is drawn down the length of the right arm to the fist clutching a shockingly large stone, which is poised to swing and strike. As in the *Adoration*, Leonardo captured a moment of highly-charged action with a realism and emotional force that had never been seen before.

His paintings aside, the records of Leonardo's Florentine years are sparse and uninformative. In 1476 he and several others were twice accused of homosexual acts in anonymous denunciations by the same hand; one of Florence's more sinister customs was to maintain a special box in which such denunciations might be posted for the attention of the authorities. But if there was an investigation, either no supporting evidence was found or the matter was quietly forgotten. At any rate we hear no more of it.

Leonardo was evidently not an intimate of Lorenzo de' Medici. The most glamorous and cultivated Renaissance prince and the greatest genius among his subjects would be expected to have formed a brilliant association, but did not;

St. Jerome. c. 1483. In this unfinished painting, the saint is mortifying the flesh by beating his chest with a large stone. Musei Vaticani, Rome.

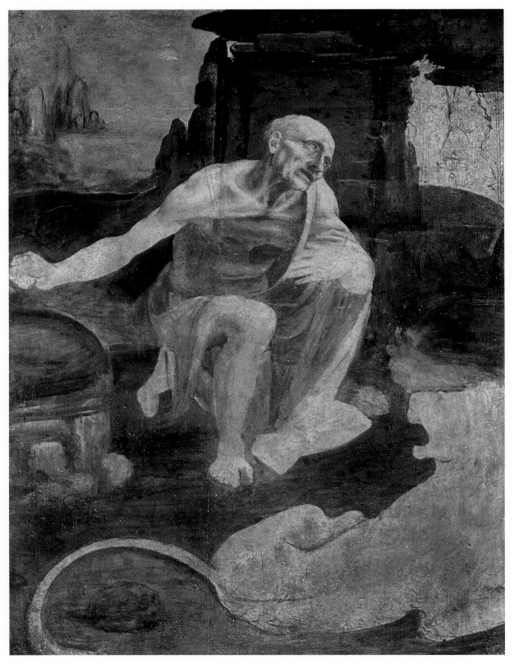

Engraving of a knot.
British Museum,
London.

as already suggested, Leonardo may have been too science-minded to fit in with the lofty poetic neoplatonism of Lorenzo's entourage. However, he was not without official patronage of which Lorenzo must have approved in advance. In 1478 Leonardo was commissioned to paint an altarpiece for the chapel of the Signoria (the town hall of Florence), though it was never delivered. And a little more than year later he made a careful drawing of a hanged man that implies that a Medici commission was in the offing for him. The man was Bernardo di Bandino Baroncelli, one of the leading actors in the Pazzi conspiracy which almost destroyed the Medici. The conspirators planned to strike down Lorenzo and his brother Giuliano and to raise the city against the Medici; the assassinations were to take place in the cathedral, at the elevation of the Host during the Easter mass – a curious piece of timing, to say the least, and one not calculated to win popular sympathy for the Pazzi. In the event everything went wrong. Giuliano was killed outright – stabbed nineteen times – but Lorenzo escaped with a wound in his neck. The people refused to join the Pazzi who, with their supporters, were hunted down; the Pope had been a party to the conspiracy, and his agent the Archbishop of Pisa was among those hanged on the spot. The Medici quest for revenge, however, had only begun. Eventually it reached as far as Constantinople, to which Baroncelli had fled; Medici agents persuaded the Sultan to hand him over, and he was hanged at Florence in December 1479. Leonardo drew the hanged man, and we can infer that he had a specific purpose in mind, since in one corner of the sheet he listed in neat mirror-writing not only the clothes worn by the dead man but their colours. He was evidently expecting or hoping to paint the occasion, though this, like so many of his projects, came to nothing.

Finally, it was Lorenzo himself who, in 1482, sent Leonardo on a mission to Milan, which was to become his new home.

LEONARDO IN MILAN

Florence passed through difficult times after the Pazzi conspiracy, and needed all the allies she could make or keep. Leonardo was sent to Milan on what we should now call a goodwill visit, intended to emphasize the friendly relations existing between the two city-states. He took with him a silver lute of his own making, in the shape of a horse's skull, which he presented to Duke Lodovico. He was chosen to make the journey because he was an acknowledged virtuoso instrumentalist, and with him went a famous singer, Atalante Migliorotti. Lorenzo de' Medici intended to make sure that his gift provided at least one night's splendid entertainment at the Milanese court.

Leonardo must have liked Milan, for he decided to settle there; he had certainly done so by April 1483, when he signed a contract to paint an altarpiece. Milan was less wealthy and sophisticated than Florence, but everything we know about Leonardo – that he was handsome, ceremoniously courteous, charming, reserved, fastidious – indicates that life attached to a court would have been more to his taste than the commercial republican hustle of Florence. There was no question of disloyalty in this, for artists were expected to go where they could find patrons. As a matter of fact, Leonardo never showed the slightest political loyalty to Florence or anywhere else, and there are no significant political statements in his voluminous writings beyond a few general remarks about the hatefulness of tyrants. But he was not simply above the fray since he worked as a military engineer for each of his masters, dealing in destruction as impartially as any mercenary. In a letter to Duke Lodovico he recommended himself as a military expert, boasting that he possessed secret techniques for portable-bridge building, undermining fortifications and designing immensely improved cannons, catapults, chariots and ships. He added almost as an afterthought that he could design buildings, paint and sculpt at least as well as any other man.

Such a combination of art and engineering was not unusual in itself; as we have seen, a master artist was expected to be a sort of universal designer, adapting himself to all his patrons' requirements. But Leonardo's claims were extravagant even for an age of shameless self-promotion and, moreover, they were untrue: the military drawings he made before going to Milan were relatively crude. It was only after settling in the city that he studied the subject in earnest, and the note-making this involved seems to have become the habit of a lifetime. The famous notebooks of Leonardo were thus begun, not in his youth, but when he was about thirty and newly arrived in Milan.

An important, though not essential, part of Leonardo's present-day fame derives from these notebooks, which became widely known only centuries after his death. They give an unparalleled insight into the workings of a great mind in pursuit of knowledge. The contents include sketches and designs, careful scientific drawings, written observations, notes of information, even Latin word-lists he proposed to memorize. Among the subjects are military and civil machinery of all kinds, design and engineering, the anatomy of human beings and animals, optics, botany, mathematics, Latin, human types from the ideal to the grotesque, and both real events and apocalyptic visions of holocaust and deluge. The notes on painting, abundant enough to be excerpted and published as a separate 'treatise', are nonetheless a small fraction of the whole, a fact which must go some way towards explaining Leonardo's relatively limited artistic output. If we insist on considering him as primarily an artist, we may come to feel that he was actually a victim of his omnivorous curiosity.

On the evidence of the notebooks Leonardo is usually presented to us as a great scientist, a worthy predecessor of men such as Galileo who overturned the medieval world-picture two or three generations later. But although the notebooks show us a mind insatiably curious and splendidly creative, it was not in the strict sense a scientific mind. Leonardo was modern in his distrust of arguments based on abstractions and generalizations, and in certain subjects, such as anatomical dissection, he was a meticulous recorder of work he had carried out himself. But, as a whole, the notebooks reveal an appetite for facts that might be described as neurotic rather than scientific; they have something in common with the compilations of antiquity and the Middle Ages in their massive, encyclopaedic, unsystematic and apparently indiscriminate nature. Leonardo's notes are frequently inconsequential, jumping from one subject to the next with confusing abruptness, as though the writer were driven impossibly hard by the urge to get everything down. This apparently feverish, universal

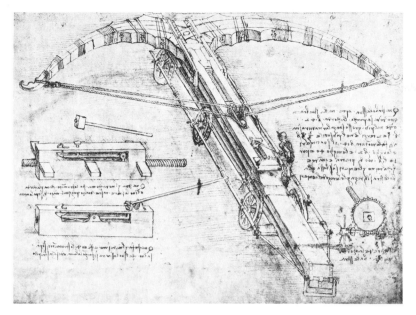

Left: War machine. This giant crossbow, like many of Leonardo's military ideas, says more for his imagination than his practicality. British Museum, London.

Below left: Drawings of skulls. 1489. Royal Library, Windsor Castle.

Below right: Studies of the bones of a bird's wing. c. 1513. The subject of flight was one to which Leonardo returned more than once in his notebooks; he even designed ingenious flying machines. Royal Library, Windsor Castle.

Bottom: Study of hands. Silverpoint drawing heightened with white, on pink prepared paper; date uncertain, but probably 1470s. Royal Library, Windsor Castle.

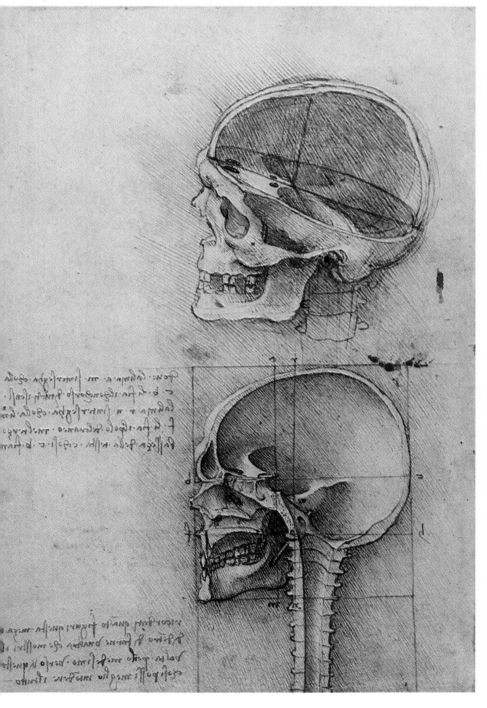

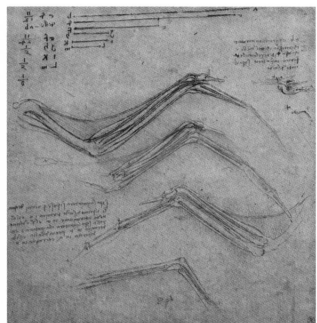

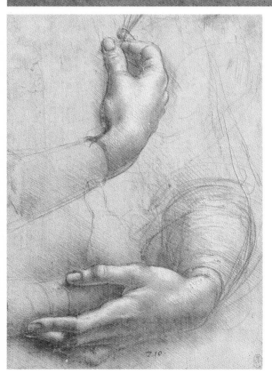

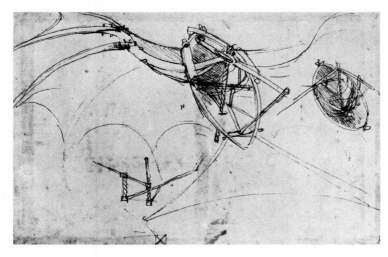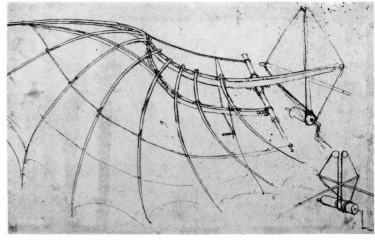

Designs for a flying
machine. Leonardo
visualized man
flying like a bird,
with artificial wings,
but he also sketched
out a kind of
helicopter. British
Museum, London.

curiosity must be contrasted with the lack of self-observation or personal detail
in the notebooks. Leonardo wrote thousands of pages, and yet left us in
ignorance of his feelings and opinions on most subjects, let alone those that
touched him the most. It very much appears as if, consciously or otherwise, he
took refuge from some unadmitted personal strains within a fortress of imper-
sonal facts whose walls he continually strengthened.

Similar reservations can be made about Leonardo's work as an engineer-
inventor. We hear much of his proposals (for armoured cars, siege engines,
earthworks, gigantic defensive structures), but little of their execution. Doubt-
less he gave sound advice on points of detail (especially concerning fortifica-
tions, where his expertise is not in serious doubt) when he was consulted, but
his own schemes tended to be visionary rather than practical. To conceive a
plausible-looking flying machine (especially one in the form of a helicopter) was
an astonishing feat for a 15th-century mind, but the design hardly came com-
plete with specifications. Like so many of Leonardo's ideas, it belongs to the
poetry of science and technology – and, since vision must precede realization,
deserves all honour for it. But there is no hiding the fact that Leonardo's godlike
conceptions went hand in hand with a certain carelessness about practical
details. His chariots have wheels with absurdly large scythes sticking out of their
hubs, as if designed to cut down armies of giants; and he dreams in vain of
diverting rivers or building topless towers for the great fortress of Milan – of
achieving the miraculous, as he had promised Lodovico, rather than the poss-
ible. In the final analysis he is an artist, not a scientist or technologist. He is
never careless about aesthetic details; yet even his art is affected by his over-
ambition and perfectionism, and no other major artist has left so many works
unfinished or liable to deterioration. All Leonardo's efforts, artistic and other-
wise, were the products of a supreme creative energy, directed and misdirected
by a curious, flawed personality.

No less than twenty-three years were to elapse between the contract for
Leonardo's first Milanese painting and its delivery – something of a record even
for him. The commission was one that has already been mentioned as evidence
of Leonardo's residence in Milan. In April 1483 he agreed to provide an altar-
piece for the Chapel of the Immaculate Conception in the Church of San
Francesco Grande, Milan. The contract specified that the painting was to be a
Virgin among rocks and mountains, shown with her son, attendant angels and
prophets, and a God the Father who would presumably be looking down upon
the scene from Heaven. The commission soon became the subject of an exten-
ded legal wrangle between Leonardo and his assistants (who wanted a revision
of terms and some more money) and the Confraternity of the Immaculate
Conception (who wanted delivery of their picture). The dispute was finally
settled in 1506, and the painting was delivered about two years later. Even so,
as the reader may see for himself, the finished work was different in many
respects from the one the Confraternity had ordered.

Matters are complicated by the fact that there are two surviving versions of
the *Virgin of the Rocks* which belong to different stylistic periods of Leonardo's
life; they are also slightly different in size and many minor details. The version
in the Musée du Louvre, Paris, must be the earlier, and is indeed like a fulfil-
ment of 15th-century Italian painting in its human warmth and freshness. The
Virgin in the National Gallery, London, is in the later High Renaissance style
of which Leonardo was one of the creators – more solemnly grand and idealized

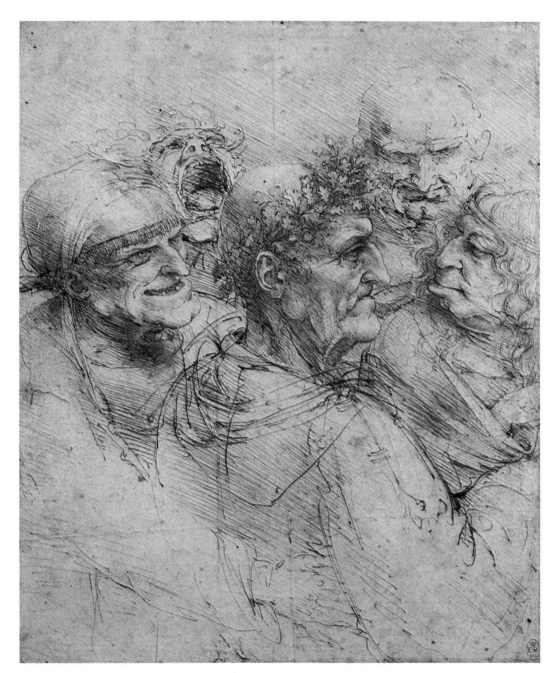

Grotesque heads. 1485 – 90. Pen and ink drawing of a subject that appealed to Leonardo – and, for that matter, to other Renaissance men. Royal Library, Windsor Castle.

and monumental than the earlier work, with the unearthly quality of the scene emphasized by the metallic light bathing faces, hands and the children's bodies. (It is, however, typical of Leonardo that the light is nevertheless a credible natural phenomenon, created by the grotto setting.) Both versions are masterpieces; which of them you respond to most fully is a matter of temperament rather than discrimination.

The Immaculate Conception of the Virgin, now a Catholic dogma, signifies that Mary, unlike all other mortals since Adam and Eve, was untouched at birth by Original Sin. Leonardo's commission was to produce the main pictorial celebration of this belief in a chapel specially dedicated to it, and the tenderly protective figure of Mary is appropriately made the focus of the composition. Her hand and robe stretch over the infant St. John the Baptist (here perhaps symbolizing vulnerable humanity), who is adoring the infant Jesus. The angel beside Jesus is a figure of wonderful beauty but, to modern eyes, introduces a note of strangeness that, while it does not injure the quality of the picture, does seem to complicate its atmosphere and meaning; the Louvre angel, with its knowing smile and mysteriously pointing finger, is a particularly disturbing presence. The rocks in both paintings provide more than a majestic background; the grotto, opening on to a distant, misty, melting landscape of rock and water, plays an important part in the emotional colouring of each picture. Inevitably, we find the damaged and unfinished works of Leonardo's young manhood a

Below: Study for the angel in the *Virgin of the Rocks. c.* 1480. Palazzo Reale, Turin.

Below right: *Virgin of the Rocks.* 1482–3. The earlier of Leonardo's two versions of the subject; it retains the sweetness of the 15th-century Florentine tradition. Musée du Louvre, Paris.

Far right: *Virgin of the Rocks.* 1506–8. Leonardo's second version of this subject is more consciously imposing, looking forward to the High Renaissance style. National Gallery, London.

little disappointing; with the *Virgin of the Rocks* we can no longer doubt that we are in the presence of a great master.

The painting Leonardo eventually delivered to the Confraternity of the Immaculate Conception was the London *Virgin of the Rocks*. There has been a good deal of argument about this in the past, but it now seems quite certain. The subsequent history of the work is known, from its placing in the chapel to its arrival at the National Gallery via the 18th-century Scottish history painter Gavin Hamilton, who bought it in Milan and took it back to Britain with him. Furthermore, the legal settlement between Leonardo and the Confraternity implied that the work was unfinished in 1506, which means that the painting Leonardo delivered must have been executed around 1506–8. The Louvre version is, as we have seen, much earlier; it has been suggested that Leonardo painted it in Florence and brought it with him when he moved to Milan in 1482/3. If there is a mystery, it is why he never presented the Confraternity with this earlier, finished work. But although we are never likely to know the solution, there seems no reason to suppose it is not a straightforward one (for example, that Leonardo had already sold or given away the earlier painting) rather than the kind of 'significant' fact that Leonardo's personality tempts us to look for.

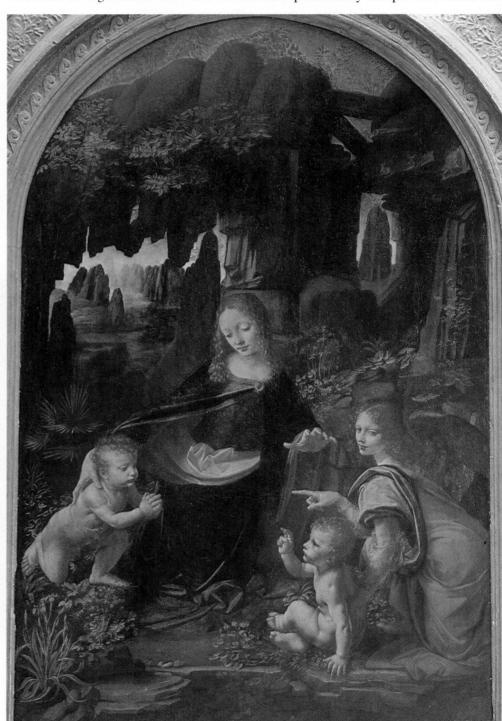

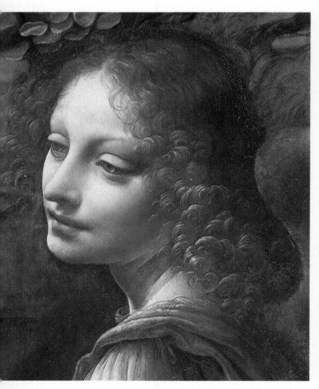

Above: Detail of the angel from Leonardo's second version of the *Virgin of the Rocks.* 1506–8. A characteristic example of Leonardo's taste for an unearthly, rather ambiguous beauty. National Gallery, London.

34

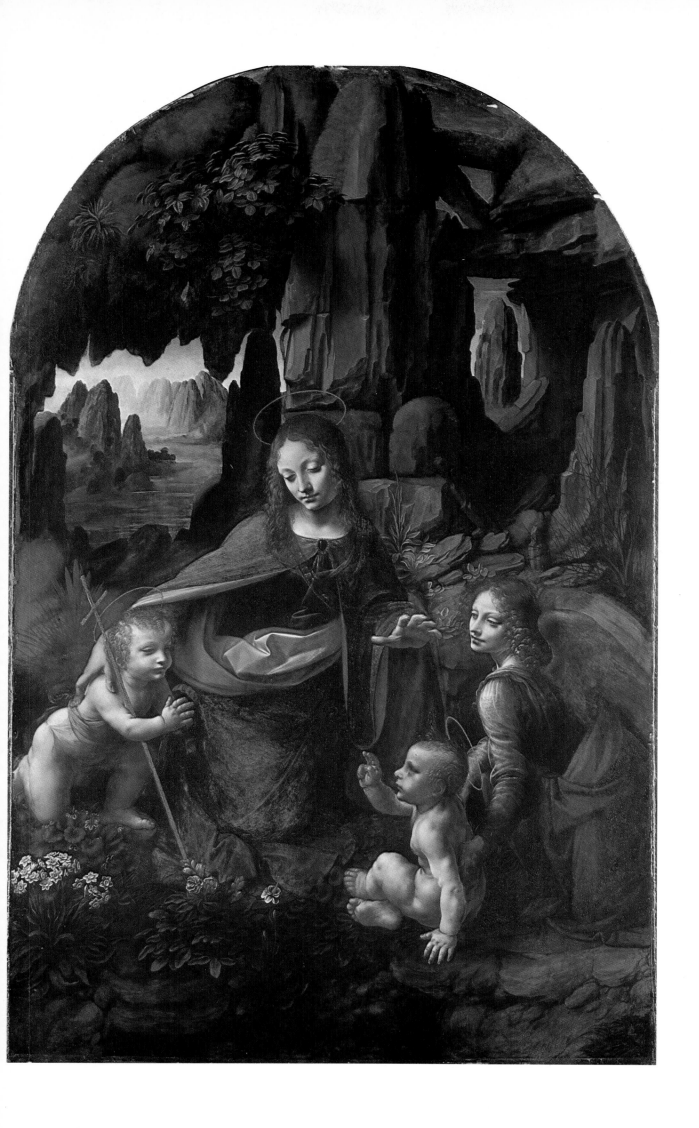

AT THE COURT OF DUKE LODOVICO

The real ruler of Milan during this period was Lodovico Sforza, called *Il Moro* ('The Moor') on account of his dark complexion. Lodovico was nominally the Duke of Bari; the rightful Duke of Milan was his nephew Gian Galeazzo Sforza, but he was only a child in 1479 when Lodovico effectively took power, and he remained under his uncle's tutelage right up to his death in 1494, when Lodovico formally succeeded him as Duke of Milan. Lodovico was in many respects a typical Renaissance despot, inclined to over-cleverness in his political activities (where he mistook a short-sighted opportunism for realism) and intent upon enhancing the splendour and cultural prestige of his court. As well as Leonardo, he employed the great architect Bramante and a good many lesser artists, and he deserves credit for bringing the Renaissance to the previously rather philistine city of Milan.

As artist-in-residence at Milan, Leonardo was expected to undertake all sorts of tasks. Lodovico presumably made some use of Leonardo's military expertise, although there is no evidence that his more ambitious ideas were adopted. He was also employed from time to time on architectural projects: in 1487 he submitted a model for the dome of Milan Cathedral (it was paid for but not used), and three years later Lodovico sent him to the Milanese city of Pavia to advise on the design of the cathedral there. At Milan itself, in Lodovico's great fortress-palace, the Castello Sforza, much of Leonardo's time must have been taken up with designing costumes, decorations and short-lived wood and plaster structures for the masques and pageants in which Renaissance man took such delight. The most famous was a 'Masque of Paradise' performed in 1490 in which nymphs and planets on a revolving stage paid homage to Isabella of Naples, who had recently become Gian Galeazzo's bride. Leonardo seems to have enjoyed this kind of work, and to have devised some allegorical pieces of his own for performance. Later he carried out at least one large-scale piece of interior decoration when, in 1498, he painted a room that still survives in one of the towers of the Castello Sforza; the walls are covered with a dense, intricate design of willows with intertwining branches that allows the spectator to imagine he is standing in a forest glade.

There is no extant record of these masques and pageants, but Leonardo no doubt enjoyed the freedom of invention they allowed him. By contrast, the painting of 'official' portraits must have been irksome to a man of his temperament. Instead of his private world of lovely mysterious faces and melting landscapes, he was forced to make a more conventional record of his sitters' beauty and eminence. The contrast is so strong that many admirers of Leonardo have been reluctant to believe that he could have painted works such as the *Lady with an Ermine* and *La Belle Ferronière*, now generally regarded as portraits of Lodovico's chief mistresses. But despite their relative conventionality these paintings are full of fine touches that can only have been applied by a master's hand. The *Lady with an Ermine* succeeds wonderfully in making its subject appear beautiful, sensitive and fascinating – as, by all accounts, she seems to have been. She was Cecilia Gallerani who became the Duke's favourite mistress in 1481, when she was in her early teens; Leonardo's portrait of her was probably done no more than three or four years afterwards. Later hands have repainted some parts and the entire background, hardening the edges of the figures so that they look more 'naïve' than Leonardo intended, charming though the effect is. Gallerani's pose, head and body angled in different directions, is rendered with such skill that we hardly notice the difficulty of execution. The ermine, however, is painted with a self-conscious virtuosity. Its presence is symbolic; it was Lodovico's personal emblem, and its name could be linked with 'Gallerani' by some ingenious verbal play in the Renaissance fashion. Leonardo nonetheless makes it an entirely believable beast, twisted round on the girl's arm, utterly alert, and directing a look of fearsome malevolence at some unwelcome presence outside the picture.

After this, *La Belle Ferronière* seems quite tame and conventional, and many doubts have been expressed about its authenticity. But the face is so beautifully and fully modelled that we sense the bone structure beneath it as well as seeing the living flesh. The painting as a whole has a dignity and emotional timbre that, if it were not by Leonardo and therefore judged by the very highest standards, would win it a good deal of admiration; the minor work of a great master generally receives less appreciation than the best work of a minor or unknown

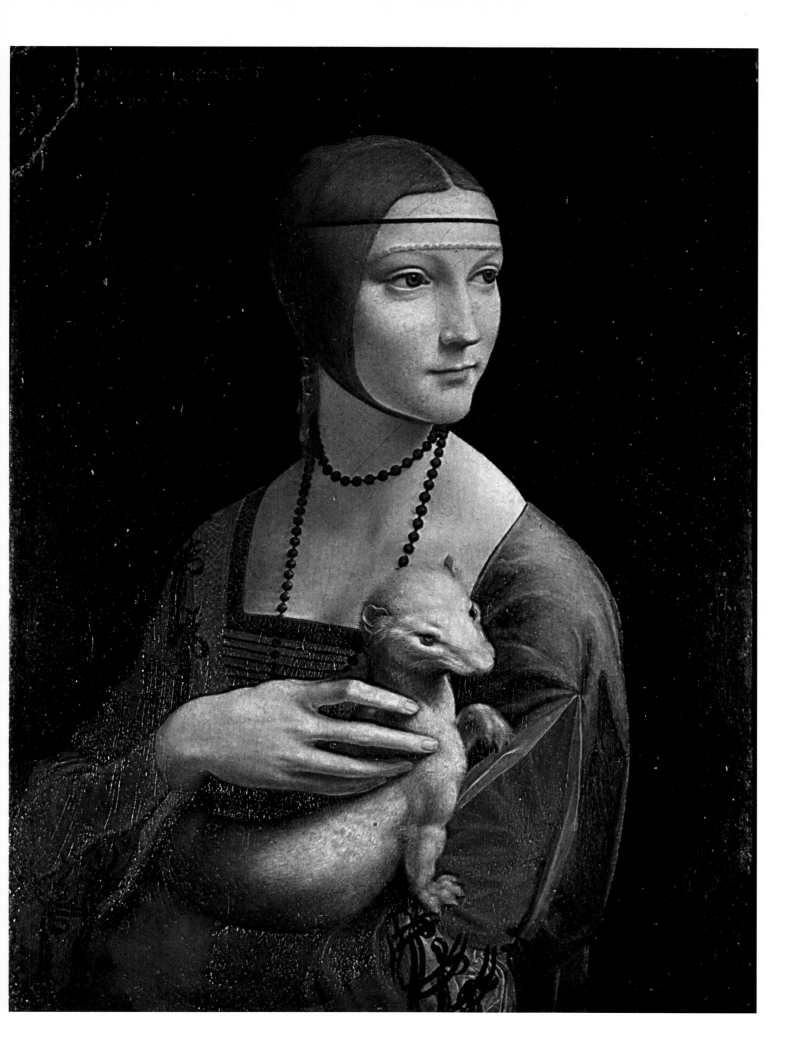

Right: *La Belle Ferronière. c.* 1490. The French title is based on an earlier misunderstanding of the picture's subject; she is probably Lucrezia Crivelli, one of the Duke of Milan's mistresses. Musée du Louvre, Paris.

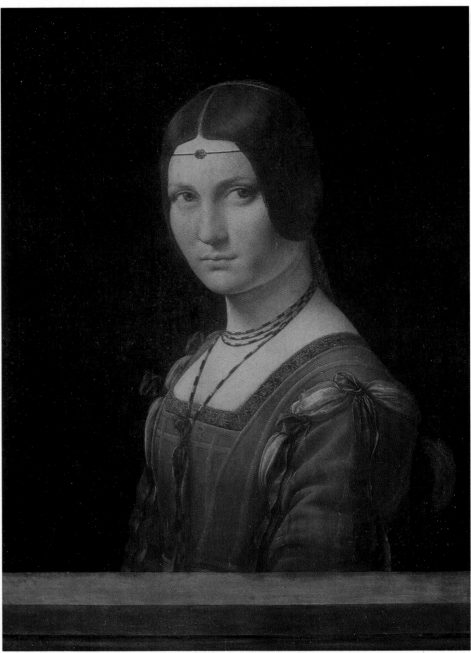

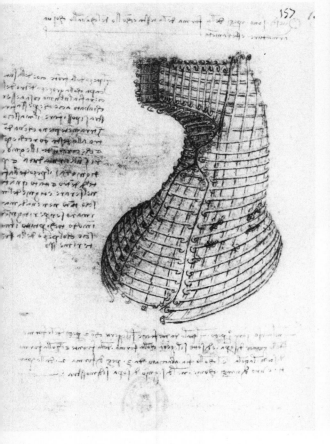

Above: Mould for the Sforza Monument. *c.* 1493. This contraption was intended to contain the mould for 'The Horse', Leonardo's famous model for the Sforza Monument, which was never cast and was eventually destroyed. Biblioteca Nacional, Madrid.

artist. The French title, incidentally, is a complete misnomer, based on the mistaken early belief that the sitter was French. The woman now most commonly put forward as the subject of the picture is Lucrezia Crivelli, who succeeded Cecilia Gallerani as Lodovico's mistress and whose portrait Leonardo is known to have painted. The only other portrait from Leonardo's years with Lodovico is a small, unfinished painting of an unknown musician. It is in excellent condition and is the only one of Leonardo's pictures in which we can study the subtle play of light on a face without allowing for the coarsening effect of thick, centuries-old varnish.

The greatest project Leonardo was called upon to execute for Lodovico was 'The Horse'. The ruling dynasty of Milan had been founded by Lodovico's father, Francesco Sforza, one of the great *condottieri* of his time; and from the 1470s, long before Leonardo's arrival, Lodovico had talked of erecting a worthy monument to him. At that time, the obvious form for such a memorial was a life-size (or even larger) bronze equestrian statue. Relevant precedents already existed in two of the most famous of all 15th-century works. Donatello's *Gattamelata* at Padua and Verrocchio's Colleoni Monument at Venice, in both of which the union of man and horse was effective in suggesting overweening pride and an irresistible urge to dominate. In fact the horse was so much the decisive element in this kind of work, giving it strength and dynamism, that in Leonardo's case we hear much more of it than we do of Francesco (an odd state of affairs, after all, in a memorial to him).

We do not know when Leonardo was awarded the commission – only when he almost lost it. In 1489 Lodovico wrote to Florence asking Lorenzo de' Medici to send him someone who could take on the job, since Leonardo's ability to accomplish it appeared doubtful; luckily for Leonardo, Lorenzo could not or would not oblige. After months of delay, during which he was occupied in creating the 'Masque of Paradise', Leonardo noted in April 1490 that he had begun to work on 'The Horse' again, and this time he quickly carried it through to completion. 'Completion' in this case meant a full-scale clay model of the statue, which would be translated into a more durable form by means of a series of moulds and casts involving clay, wax and, finally, bronze. The casting had to be put off until Lodovico could accumulate a sufficient quantity of bronze, but in the meantime the model was shown publicly in November 1493, during celebrations of the Emperor Maximilian's betrothal to Bianca Maria Sforza. 'The Horse' was regarded as a miraculous achievement, and made Leonardo a famous man. But misfortune overtook this work, like so many others from his hand. Lodovico acquired enough bronze to begin casting, but decided instead to send the material to his father-in-law, who urgently needed cannon; the casting was never done, presumably because bronze was so much in demand during the turbulent period that began in 1494 with the French invasion and

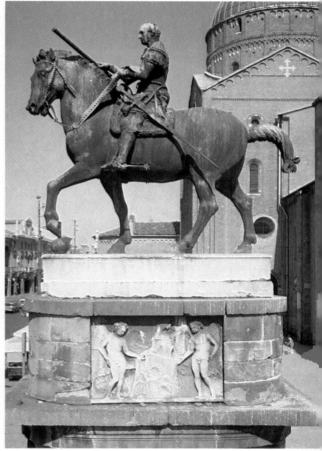

Below: Donatello. *Gattamelata*. One of the great Renaissance equestrian statues. Leonardo's lost Sforza Monument was regarded as having surpassed this and Verrocchio's equally famous Colleoni Monument. Padua.

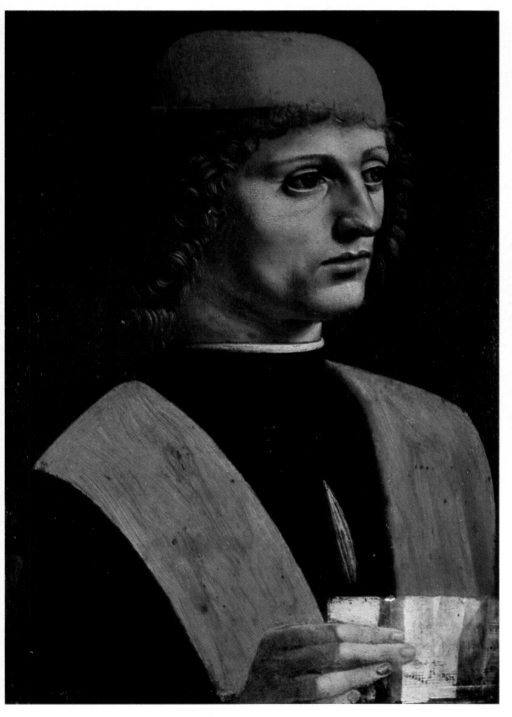

Left: *The Musician. c.* 1485–90. Attributed to Leonardo. Biblioteca Ambrosiana, Milan.

Below: Head of a Young Man. *c.* 1504. This drawing, in red chalk on red prepared paper, is probably a portrait of Salai, a young man who had a close relationship with Leonardo until the artist's final years. The hair is touched with black chalk. Royal Library, Windsor Castle.

Above: Study for *The Last Supper*, with architectural and geometrical designs. Royal Library, Windsor Castle.

Right: Studies for *The Last Supper*; red chalk drawing. Galleria dell' Accademia, Venice.

a new round of Italian wars; five years later, when the French entered Milan in triumph, Gascon archers used The Horse for target practice, effectively destroying it.

Leonardo's notebook for this period offers a rare glimpse of his private life. In July 1490 he took into his service a ten-year-old boy whom he nicknamed Salai, 'Little Devil', and at once it became apparent that Salai was a shameless thief. He stole some money from Leonardo the day after he moved in, and the notebooks record a long list of his subsequent crimes – thefts from both Leonardo and his friends, including Turkish leather and silverpoint drawings, which the boy sold to buy sweets. In the margin of a page Leonardo has scribbled irritably, 'thievish, lying, obstinate, a glutton' to describe Salai. Yet he spent a great deal of money on clothes for Salai, put up with his tricks for years, continued to see him after he had grown up, and in his will left his sometime servant a half share in a vineyard. Since Salai's main recommendation seems to have been his good looks, it is virtually certain that he was Leonardo's lover.

Leonardo's homosexuality has often been hotly denied, though all the probabilities are in its favour. He was denounced for sodomy in Florence; he behaved like the all-suffering lover with Salai; all his intimate friends were male; and his contemporaries seem to have taken his inversion for granted. Cultivated Italians were generally tolerant in such matters, partly influenced by the prestige of the ancient Greeks, many of whom claimed to find a special nobility in relationships between man and boy. (The religious and legal situation was, as it is so often, out of step with social norms, threatening the homosexual with death at the stake if convicted, and damnation if he remained unrepentant.) In his life of Leonardo, first published in 1550, Vasari refers significantly but inexplicitly to the artist's friendships with Salai and another young man, Francesco de' Melzi, whom he was to adopt as his heir. By the time Vasari was writing, the Catholic Counter-Reformation was in full swing, and attitudes had hardened. This probably accounts for Vasari's caution, which later moved him to delete a reference to Leonardo's atheism that had appeared in the first edition of the *Lives*. Since Leonardo was already dead, we must suppose that Vasari was concerned for the good name of artists in general. He was not far wrong about Leonardo's heterodoxy: in his notebooks Leonardo is scathing about beliefs such as the intercession of the saints, and dismisses the existence of God as an undemonstrable proposition that was meaningless to discuss. Though he took care to get his pictorial references right when painting a religious subject, there is no evidence that he had any interest in the legendary, theological or ritual aspects of Christianity. On the contrary, if he was not exactly a scientist, he did have an exclusive reverence for the empirical facts on which science was to base itself.

For us, the only significance of Leonardo's religious opinions and sexual tastes is their influence on his mind and art. Did his 'atheism' or his homosexuality make him restless, avid for the security of facts, a perfectionist

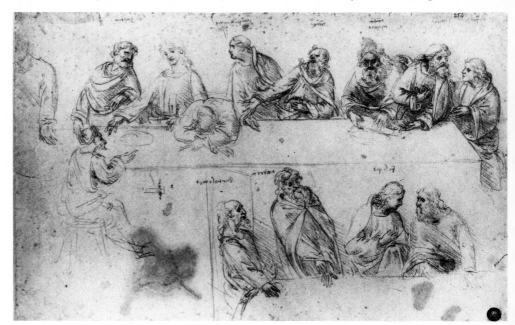

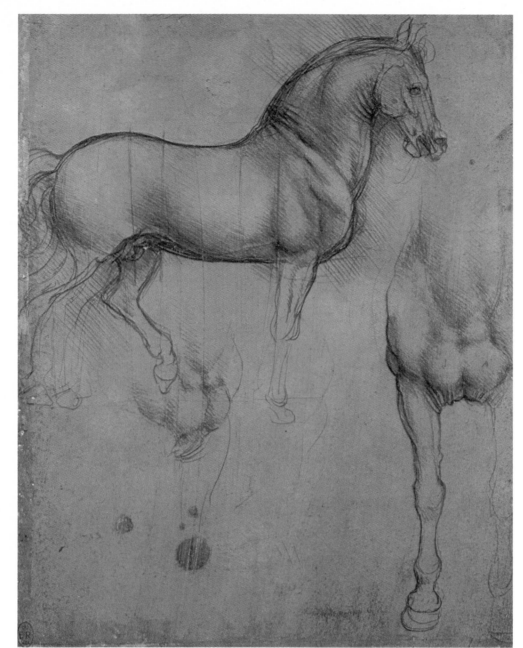

Sketches for the Sforza Monument. These elegant drawings were done (in the early 1490s) with a silverpoint pencil on prepared blue paper. They give us some idea of how the horse in his lost bronze monument to Francesco Sforza was intended to look. Royal Library, Windsor Castle.

Sketch for the Sforza Monument. Before 1490. An early sketch for the Monument. The pose with a horse rearing and trampling a prostrate foe must have been too ambitious for contemporary bronze-casting techniques, and Leonardo abandoned it. Royal Library, Windsor Castle.

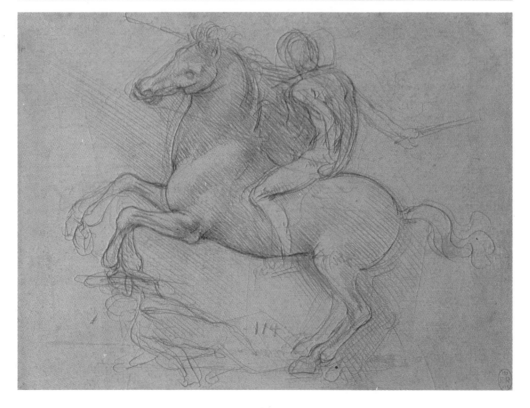

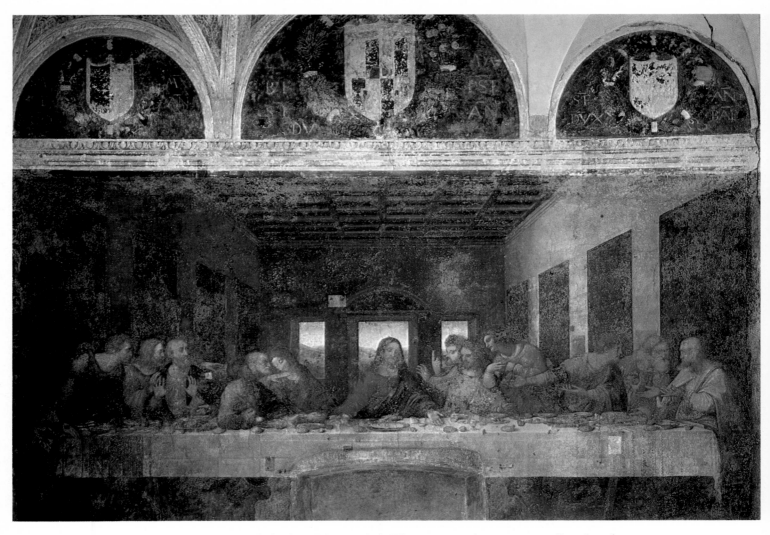

The Last Supper.
1498. This wall
painting, regarded
by contemporaries
as Leonardo's
masterpiece, began
to deteriorate even
during his lifetime.
Santa Maria delle
Grazie, Milan.

who had trouble finishing his works? The connections may well exist, but attempts to identify them have so far amounted to no more than psychoanalytical speculations based on debatable theories and inadequate evidence – a state of affairs that Leonardo himself would have regarded as absurd.

Atheist or not, Leonardo followed his secular triumph, 'The Horse', with a religious masterpiece. In 1495 he began to paint a Last Supper on a refectory wall of Santa Maria delle Grazie, a convent of Dominican friars. The work seems to have been carried out on the instructions of Duke Lodovico, who took a benevolent interest in the affairs of the convent; he certainly intervened in June 1497 to order Leonardo to hurry up and finish. By early 1498 he had done so; and his *Last Supper* was at once universally acclaimed.

'The Horse' and the *Last Supper* were the works that made Leonardo famous in his own lifetime – and within that lifetime 'The Horse' was destroyed and the *Last Supper* had begun visibly to decay. The fate of 'The Horse' may have been a matter of bad luck, but Leonardo's obsessive perfectionism was directly to blame for the disaster that overtook the *Last Supper*. The traditional technique for wall painting was *fresco* ('fresh'), which entailed painting with water-based colours on plaster that was still wet; by the time they had dried out, paint and plaster had become completely integrated by a chemical reaction, and the result could be expected to remain intact for centuries. Because the plaster had to be wet, the painter was compelled to work quickly, creating broad rather than detailed effects with his clear, distinctive colours. Leonardo employed a clay base and a binding medium incorporating oil and varnish, presumably so that he could achieve the richness of colour and fine detail of an easel painting in oils. Matteo Bandello, a contemporary short-story writer, described how Leonardo sometimes spent all day painting from sunrise to dusk, but on other occasions would only leave the Castello Sforza on impulse, add a few brush-strokes to one of the figures, and then rush off again – a proceeding that would have been quite impossible with the laboriously premeditated fresco technique. Unfortunately, Leonardo's experimental method failed disastrously; the paint became discoloured from the dampness of the wall, while it also cracked and peeled off

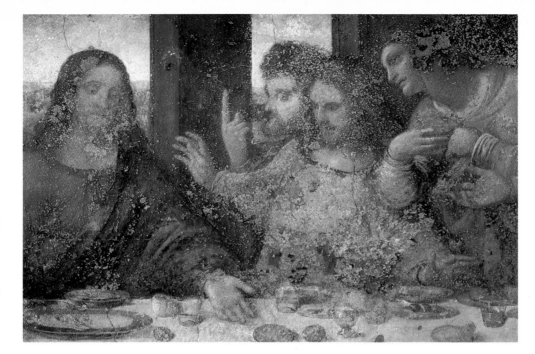

Detail of Christ and disciples from *The Last Supper*. 1498. The disciples react with horror or concern at Christ's announcement that one of them will betray him. Santa Maria delle Grazie, Milan.

the clay. By the mid-17th century the picture was being described as no longer intelligible, and the friars of Santa Maria delle Grazie felt that so little of value remained that they might as well cut away the lower part to create a new doorway. All the same, a whole series of repaintings and 'restorations' was carried out over the centuries, each less convincingly related to Leonardo's conception than the last. During the Second World War the convent was bombed but, though the refectory was destroyed, the *Last Supper* survived behind a screen of sandbags. In the post-war years the painting was entrusted to a skilled restorer armed with scientific techniques and materials; he removed the overpainting of centuries and firmly secured the surviving parts of the original to the wall. We are now able to see more of the authentic work by Leonardo on the *Last Supper* than was available to anyone for at least the previous two centuries.

But what we now see is the noble ruin of a painting. When a work is so famous and so saturated in history, it becomes difficult to achieve a genuine response to it; we make ourselves try to see it as it was meant to be rather than as it is, which is an understandable and perhaps even a legitimate exercise. The most tragic loss has been in the subtle modelling and expressive variety of the faces, on which we can be sure Leonardo lavished the full resources of his art (in fact he is known to have carried a sketchbook about with him in the streets in order to record on-the-spot impressions of suitable types); but as we now see them they are sadly blurred and battered. It is therefore the broader features of the *Last Supper* – the gestures and poses and composition – that have survived best and tend to monopolize the attention, probably creating a more unrelievedly dramatic effect than the original was intended to do. Leonardo has chosen the

Detail of the disciples from *The Last Supper*. 1498. Santa Maria delle Grazie, Milan.

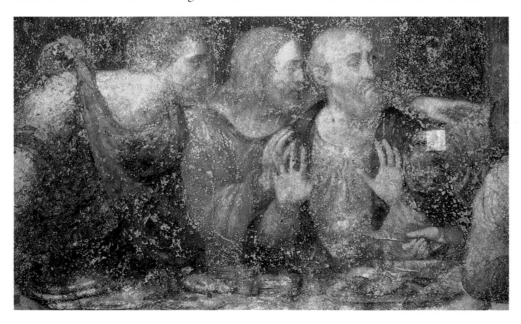

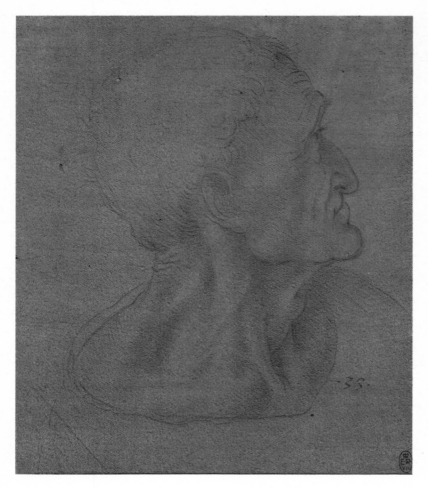

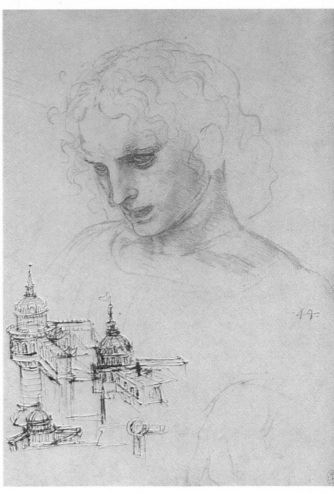

Study of a head. 1498. This drawing, in red chalk on red paper, may be a study for *The Last Supper*. Royal Library, Windsor Castle.

moment at which Jesus has just announced that one of the disciples will betray him. They react with horror, with amazement, with anger, with protestations of innocence; some half-rise from their places, others chatter excitedly among themselves. Nothing like this dynamic interaction between a group of people had ever been seen before. The skill with which their gestures are varied has always been admired; yet, despite the variety, most of their hands are so arranged that they lie along an invisible line of force that flows towards the calm, authoritative person of Jesus. He is the dominant figure, set slightly apart from the others and in the centre of the picture. Even the perspective is used to reinforce this dominance; Jesus' head is placed at the vanishing point, which is to say the point at which the 'parallel lines' receding into the picture space (the lines of the walls, for example) appear to meet (and therefore vanish) on the horizon. The diffuse turmoil of the human drama heralds and is finally absorbed into the lonely drama of divine sacrifice.

Leonardo's achievements in the 1490s made Milan one of the major Italian attractions for artists and other cultivated visitors, but Duke Lodovico had little time to relish this state of affairs. In the course of his diplomatic manoeuvring he made the mistake of encouraging the French to enter Italy and assert their king's claim to the throne of Naples, one of Lodovico's enemies. Then he made the still greater mistake of becoming alarmed by French successes and joining an alliance against them. The French were driven out, but when they returned – this time with their eyes on Milan – Lodovico found himself isolated as a result of his earlier duplicities. The French entered the city in September 1499 while Lodovico fled to Germany; the following year he briefly recaptured the city with the aid of mercenaries, only to be defeated again and taken by the French. He spent the last eight years of his life miserably imprisoned in a French fortress. Before he died he scratched '*Infelix sum*' ('I am wretched') on the wall of his cell.

Leonardo's reaction was characteristic. He sent a large sum of money to Florence for safe-keeping, and by December 1499 had left French-occupied Milan in search of a new patron. He made no attempt to join Lodovico's ill-fated attempt to recover Milan. Later the artist noted, 'The Duke lost his realm and his possessions and his liberty, and brought none of his projects to completion,' a detached summing-up, the final phrase of which reads curiously like the comment of one artist on another.

Study of a head. 1498. This drawing on red prepared paper is a study for the figure of St. James The Greater in *The Last Supper*. It is done in red chalk, but the hair is touched with black. Royal Library, Windsor Castle.

RETURN TO FLORENCE

Leonardo's position at the court of Milan had given him time and security to work and study. Now, after some seventeen years, he was compelled to travel in search of a new refuge. He stayed briefly at Mantua, where the marchioness, Isabella d'Este, prevailed on him to make a drawing of her. He must have found her tiresome, for he soon slipped away; and although she wrote to him for years asking him to paint her portrait, he never did. Then he tried Venice, hoping for lucrative employment as a military expert in the war then raging against the Turks. He projected a dam on the River Isonzo with floodgates that the Venetians could raise to inundate their enemies, and it may have been at this time that he made designs for a kind of submarine, a quite remarkable conception for the year 1500. One of the few fantasies Leonardo confided to his notebooks in any detail was that of making a fortune with his inventions, and his stay in Venice was one such occasion of fantasy. In imagination he captured the Turkish fleet and rewarded himself with an enormous ransom. But nothing came of it; we do not even know whether Leonardo's sketches ever reached the eyes of the Venetian authorities. He soon left the city and was back in his native Florence by April 1500.

He found the city much changed. The Medici had been driven out and Florence had passed through a period of extreme puritanism under a fanatical monk named Savonarola, who caused paintings, jewellery and similar items to be consigned to a 'bonfire of vanities'; Leonardo's contemporary, Sandro Botticelli, is said to have become a follower of Savonarola and to have given up

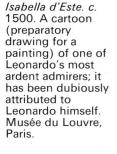

Isabella d'Este. c. 1500. A cartoon (preparatory drawing for a painting) of one of Leonardo's most ardent admirers; it has been dubiously attributed to Leonardo himself. Musée du Louvre, Paris.

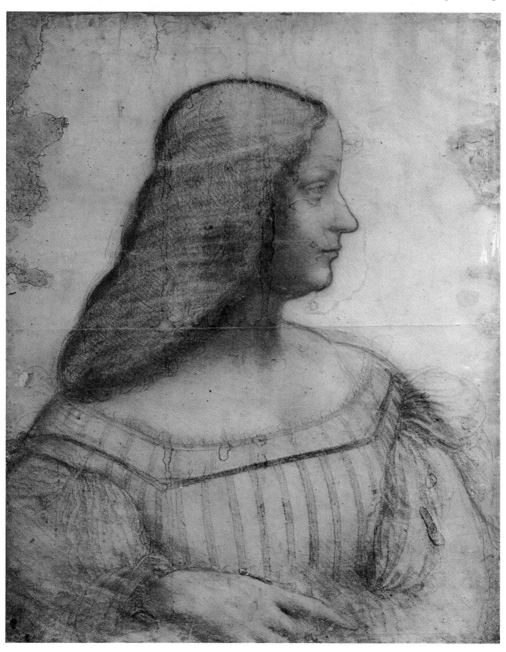

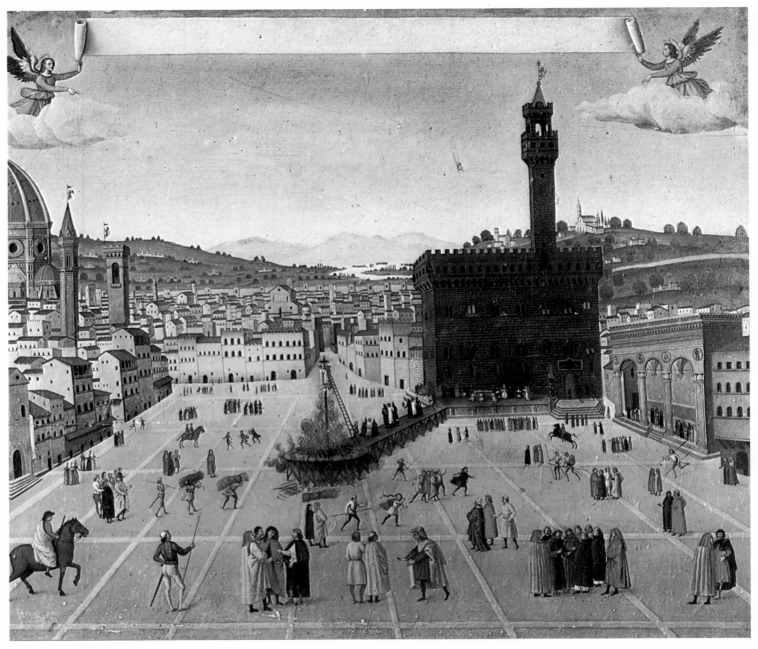

painting as a result. Savonarola had finally alienated both Pope and people and had been burned at the stake, but the atmosphere in Florence was still somewhat gloomy. In addition, the exiled Medici remained a threat to Florentine security, though for the moment the city was firmly republican.

Leonardo's first commission after his return was an altarpiece for the Servite monks of the Annunziata; according to Vasari, the contract had been awarded to Filippino Lippi, who gracefully gave it up when Leonardo – now a legendary figure – expressed his interest in the project. The monks housed Leonardo and paid his household expenses, but for a long time he appeared to do nothing. Eventually he produced a cartoon – that is, a full-scale drawing which represented the final step before work began on the painting itself. A cartoon was not a study or general guide (let alone a visual joke!) but a technical aid; usually the cartoon was transferred directly onto a panel or canvas, for example by pin-pricking along all the lines on the paper and blowing charcoal through onto the surface to be painted.

Leonardo's cartoon was such a marvel that for two days people thronged the room where it had been put on display. It showed the Virgin Mary, her mother St. Anne, the infant Jesus, and the boy St. John playing with a lamb. The sole existing cartoon resembling this has no lamb in it, which means either that Leonardo made more than one cartoon or that the description of it (by Vasari) is inaccurate. The surviving cartoon, done on brown paper in black chalk heightened with white, shows the Virgin on her mother's lap – a curious conception which evidently fascinated Leonardo, since he was to use it again as the

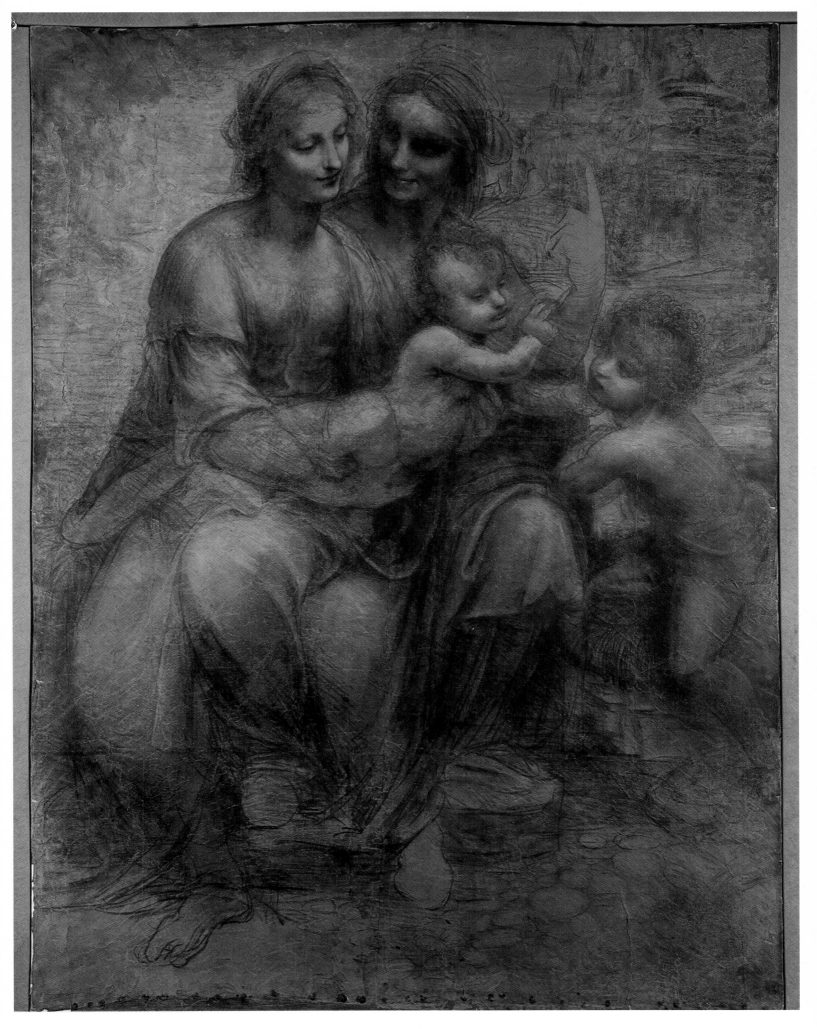

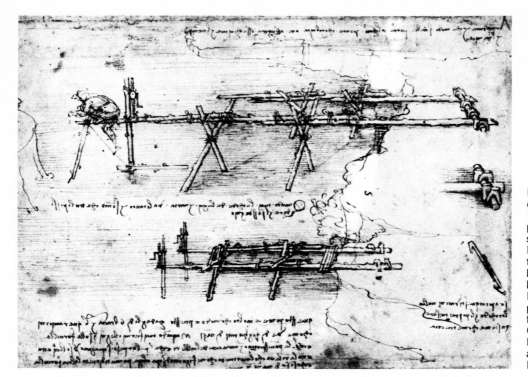

Design showing a method of constructing a trestle bridge. Biblioteca Ambrosiana, Milan.

Right: *Virgin and Child with a Yarn Winder,* a fine painting of the subject which Leonardo is known to have painted, believed to have been acquired in France by the present owner's family around 1670. Collection of the Duke of Buccleuch and Queensberry, K.T.

subject of a painting. His employment of *chiaroscuro* to create solid, believable human beings is never more evident than in this cartoon; yet there is a characteristic unearthly strangeness in the soft shadowed faces with mysterious smiles, and in the physical connection which makes the two women seem to merge into a two-headed, four-legged creature. Even more than most of his other works, this cartoon combines an utterly faithful realism with an indefinable strangeness of atmosphere.

The history of the cartoon provides an ironic insight into the making of a reputation. For almost two hundred years it was kept in the Royal Academy collection in London without attracting much popular attention. Then its sale abroad became a possibility and the alarm was raised; a public subscription and a contribution from the Government 'saved it for the nation', and in 1962 it became part of the National Gallery collection in London, reverently exhibited all by itself in a small room equipped with special lighting.

The Servites of the Annunziata never got their Leonardo altarpiece. We next hear of him painting a 'Virgin and Child with a Yarn Winder', a much-admired work in which the infant Jesus was shown reaching for his mother's winder, an object significantly made in the shape of a cross; even as a baby he recognizes his destiny and embraces it. His mother watches with an expression of consternation on her face.

By 1502 Leonardo was feeling restless. He was deeply immersed in mathematical studies and was driven out of patience by demands on his time for paintings. At one point he even wrote to the Turkish ambassador in Rome, offering his services to the Sultan; fired by the prospect, he sketched out a bridge intended to stretch across the great harbour of the Golden Horn, linking Constantinople and Pera – neither of which, of course, he had ever seen. Leonardo's behaviour that year seems perverse in terms of modern political affiliations. Since the Sultan – the enemy of Christendom – was slow to respond, Leonardo took service as a military engineer under the most notorious man in Italy. Cesare Borgia was the ruthless, conscienceless son of Pope Alexander VI, himself chiefly remembered for his exceptionally scandalous life. Thanks to Alexander, Cesare had become an archbishop and a cardinal while still in his teens; then he discovered secular ambitions, was permitted to renounce his vows, and took command of the papal army. When Leonardo joined him, Cesare was steadily conquering one central Italian principality after another, nominally in pursuit of papal claims to sovereignty but actually with the intention of carving out an independent kingdom for himself. Legend has pictured all the Borgias as skilled poisoners and employers of assassins, and Cesare was widely believed to have done away with his own elder brother, but, even if there were no truth in the legends, Cesare would still rank as a monster of cruelty and ruthlessness. Leonardo was with him when he captured Urbino – supposedly his ally – by

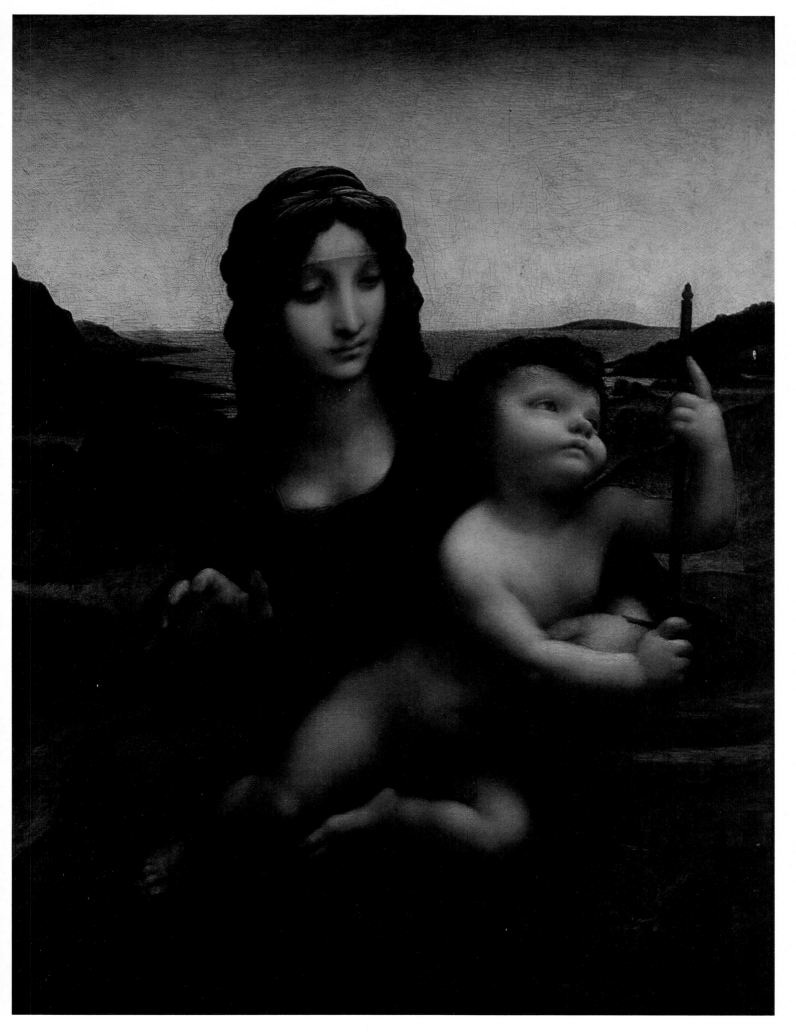

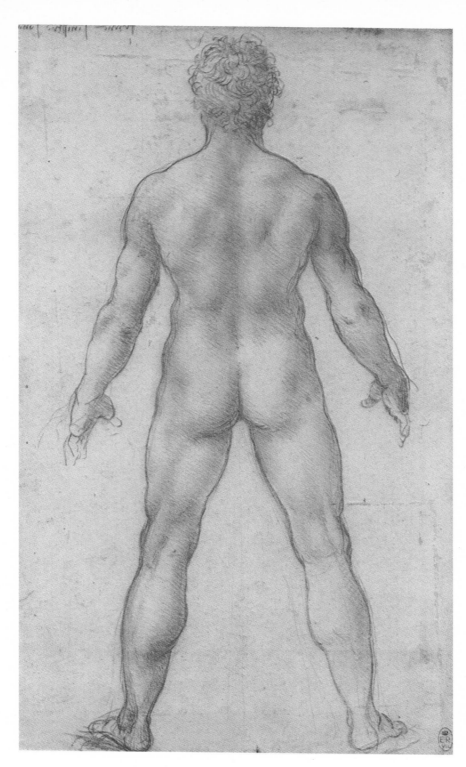

an act of outright treachery, and also when Cesare's own mercenary soldiers briefly revolted and besieged him in Imola.

Whether any of this shocked Leonardo we do not know; as usual, the notebooks contain nothing about his personal and political involvements. As Cesare's 'architect and chief engineer' he received authorization to inspect and improve military installations in any part of the Borgia domains; he made extensive notes on everything he saw during his travels, planned to drain the marshes around Piombino, designed an ideal city and created some superb maps. But by the spring of 1503 he had given up his position and was back in Florence. It is possible that Cesare's villainy was too much even for Leonardo's political detachment. (In December Cesare, apparently reconciled with his rebellious mercenaries, had invited their leaders to a banquet, arrested them, and had them strangled. One of them is known to have been a friend of Leonardo.) Or, as a man of fifty (quite old by 16th-century standards), he may have found life in the wake of a conquering army an over-strenuous contrast to his settled artist's existence at Florence and Milan. Whatever his reasons, his timing was excellent. The Pope died shortly afterwards and Cesare was immediately stripped of his power; he was killed a few years later in an obscure skirmish.

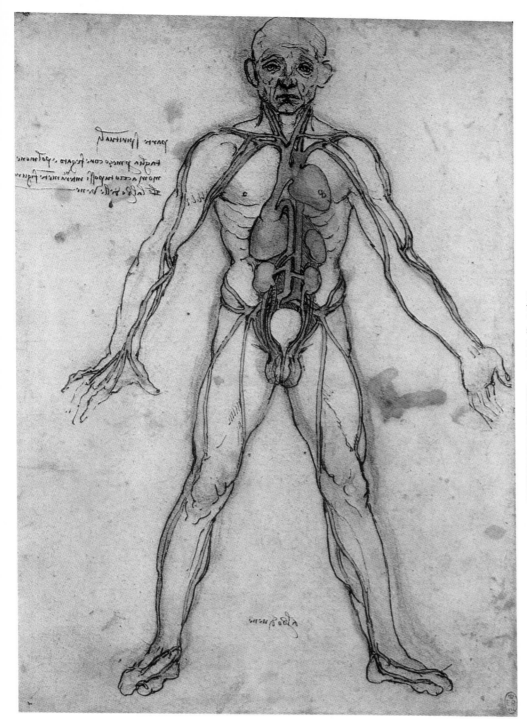

Cesare was unlucky; he might have succeeded in holding onto his conquests had he not fallen ill at the very moment his father died, leaving the enemies of the Borgias a free hand . . . or so says Niccolò Machiavelli, whose classic *The Prince*, a study of political realism, is largely based on Cesare's career.

Leonardo and Machiavelli had met and become friends at Urbino while Machiavelli was visiting the city on a diplomatic mission to Cesare Borgia. Machiavelli was high in the councils of the Florentine republic, and his influence was probably decisive in securing two important commissions for Leonardo on his return to the city. The first gave the go-ahead for his proposal to divert the waters of the Arno so that they would by-pass (and therefore ruin) the rival city of Pisa – a characteristically grandiose scheme that was for once given a proper trial before being abandoned as impracticable in October 1504. The second was a commission for a large wall painting in the Grand Council Chamber of the Palazzo Vecchio (the Town Hall, where the Signoria, the governing body of Florence, met). The given subject was the battle of Anghiari, a cavalry encounter of 1440 in which the Florentines defeated a mixed force of Tuscans and Milanese. It was a highly suitable task for Leonardo with his mastery of depicting horses, his knowledge of anatomy, and his penchant for

twisting and turning movements. Deliberately or not, the Signoria turned the occasion into a kind of public competition by employing Michelangelo to paint a different battle scene on another wall of the same room. This was pitting a rising young Florentine genius (Michelangelo was twenty-eight) against the great master of the previous generation; and the situation was all the more piquant in that the two men were known to dislike each other. Michelangelo already had some great achievements to his credit, notably a colossal *David* which had been erected in the town centre; Leonardo cannot have felt too hostile towards his young rival since he agreed to serve on the committee to advise on the choice of site.

In the event, neither of the titans fulfilled his contract. Michelangelo drew a huge cartoon for his *Battle of Cascina* but never executed the painting. Leonardo completed the central part of his, showing a struggle for the possession of a standard, but as with the *Last Supper* he seems to have been beset by technical difficulties of his own making. When he tried to dry out the painting (by setting up braziers in the council chamber) the upper part of his work darkened and the lower part started to run. Something worth looking at survived, for the 'Struggle for the Standard' remained one of the sights of Florence for sixty years, until it either deteriorated too much or went out of fashion; in 1565 it was replaced by a mediocre battle scene painted by the biographer of Leonardo and other artists, Giorgio Vasari. Sketches by Leonardo and copies by other hands remain, but they give us only a dim idea of the original. The finest copy (which is, in fact, only a copy of a copy) was made by the great Flemish painter Rubens, who inevitably put as much of himself as of Leonardo into his drawing.

Leonardo's years in Florence were highly productive, and his *Mona Lisa* has generally been dated to this period. It is almost certainly the most famous painting in the Western world, and probably the only one that virtually everybody can recognize and name. It has been stolen and recovered in dramatic circumstances, surrealized by the addition of a moustache, made the subject of a popular song ('the lady with the mystic smile'), and used to advertise cream cakes. The name of the painting comes from Vasari, who tells us that the sitter was Madonna Lisa Gherhardini ('Mona' is simply a contraction of 'Madonna', meaning 'My Lady' or 'Madam'). She was the wife of Francesco del Giocondo, a prominent Florentine merchant who gave Leonardo the commission. (The painting is sometimes also called *La Gioconda*, after Madonna Lisa's married name.) If Francesco ever expected to own the portrait and show it off to his friends, his expectations were doomed to disappointment; after spending four years on it, Leonardo could not bear to part with his work and eventually carried it off with him to his last home in France, the reason why it is in the possession of the Louvre today.

As we now see it, the *Mona Lisa* is a collaboration between art and time, impossible to look at with fresh eyes or to imagine other than it is. Only when we read Vasari, who praised the naturalism of the painting and drew an enraptured word-picture of Mona Lisa's lustrous eyes, rosy flesh tones and red lips,

Studies for *The Battle of Anghiari*. Galleria dell' Accademia, Venice.

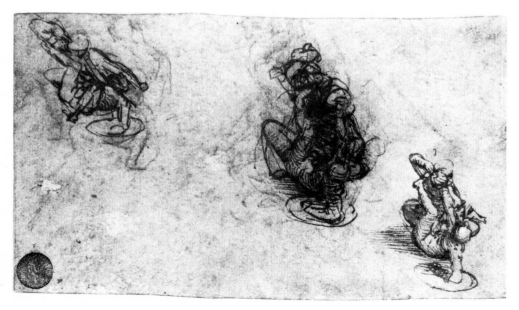

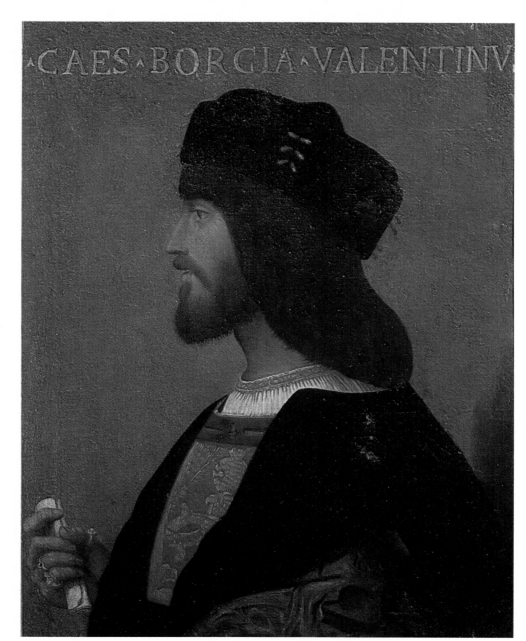

CAES·BORGIA·VALENTINV

Right: Anonymous. *Cesare Borgia.* An anonymous portrait of the ruthless son of Pope Alexander VI, who tried to build up a principality for himself in Central Italy. He was, briefly, Leonardo's employer. Palazzo Vecchio, Venice.

Below: *The Battle of the Standard.* An early oil painting copying the central scene of Leonardo's destroyed *Battle of Anghiari.* Leonardo was universally recognized by contemporaries as the supreme master of depicting horses in action. Galleria degli Uffizi, Florence.

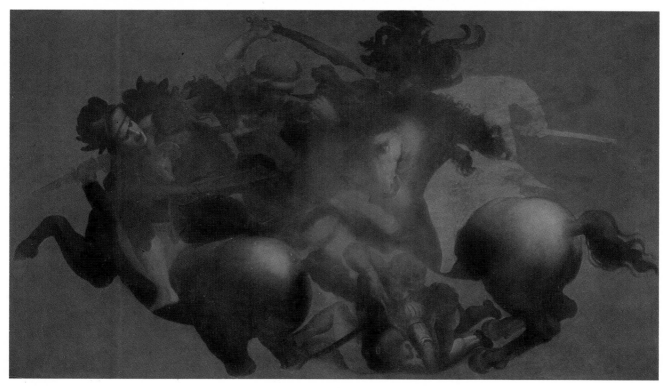

do we begin to realize how much her appearance has been modified by age and varnish. The aqueous yellow-green atmosphere does not belong to Leonardo's original conception; some of the picture's mysterious quality, at least, is accidental. On the other hand, the Mona Lisa's smile was described by Vasari as 'more divine than human', indicating that its strange, special quality was appreciated in the 16th century as well as in later times; Vasari said that Leonardo employed musicians and jesters to prevent his sitter from losing her smile and lapsing into an expression of conventional melancholy. The misty landscape of towering rocks, too, is distinctively Leonardesque, adding a consciously romantic element to the work. Tender, all-knowing and inscrutable, Mona Lisa inevitably calls to mind ideas of 'Eternal Womanhood'. This aspect of her appeal was memorably expressed in a famous description by Walter Pater, a 19th-century English aesthete whose purple prose is at its most highly (not to say over) wrought here:

> She is older than the rocks among which she sits; like the vampire, she has been dead many times, and learned the secrets of the grave; and has been a diver in deep seas, and kept their fallen day about her; and trafficked for strange webs with Eastern merchants, and, as Leda, was the mother of Helen of Troy, and, as Saint Anne, the mother of Mary; and all this has been to her but as the sound of lyres and flutes.

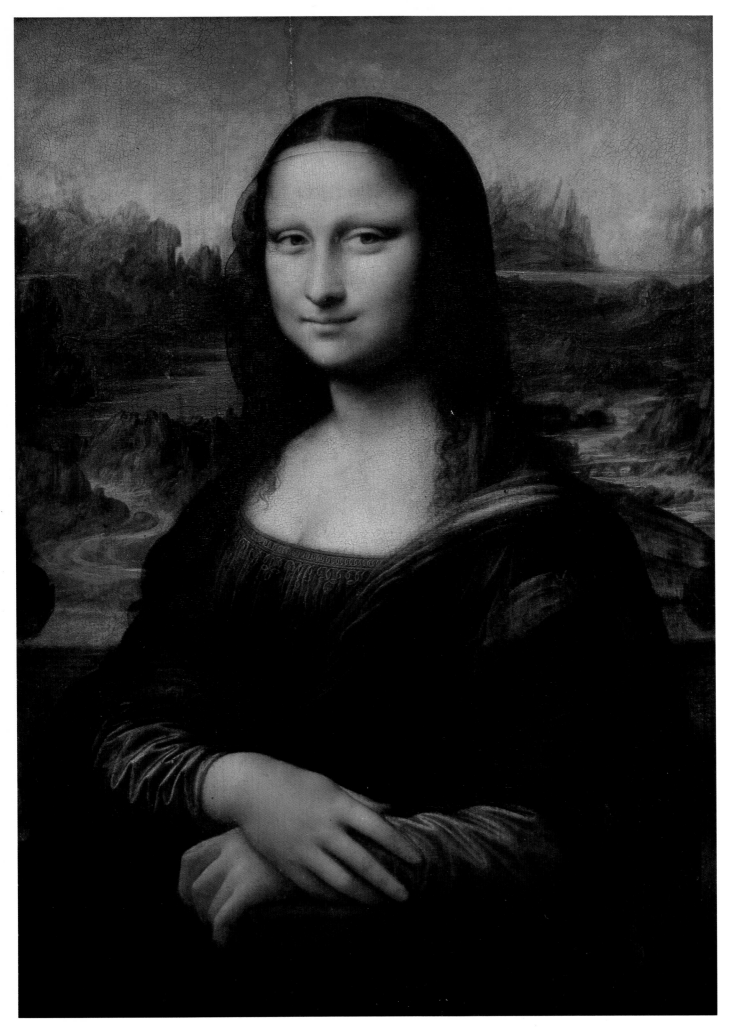

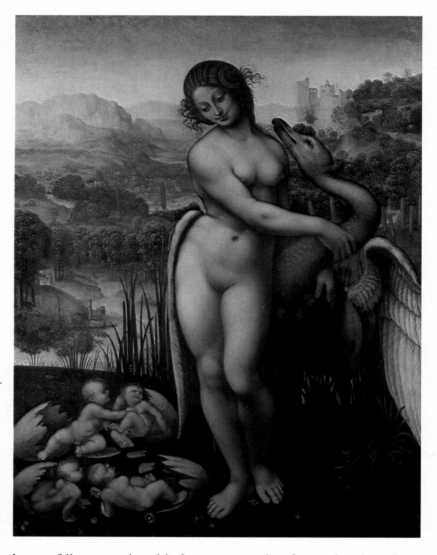

Cesare da Sesto. *Leda and the Swan.* c. 1508. A copy of Leonardo's lost painting, by one of his followers. In Greek myth, Leda gave birth to two children by Zeus, king of the gods, who had disguised himself as a swan. Collection of the Earl of Pembroke, Wilton House.

Right: *Leda and the Swan.* Another copy of Leonardo's lost painting, or perhaps of a separate cartoon by him on the same subject. Galleria Borghese, Rome.

Pater has craftily woven into his fantasy two other figures in whom Leonardo embodied his feelings about women. St. Anne is more mysterious than her daughter Mary – more the 'Leonardo type' – in both the National Gallery cartoon and the later painting. And Leonardo's Leda was also a mother, but one with a curious quality of self-conscious modesty, if we can judge from the copies of Leonardo's work that survive (the original was mentioned as being in the French royal collection at Fontainebleau during the 17th century, but has never been heard of since). In Greek myth Leda was a queen of Sparta whom Zeus, the king of the gods, seduced. In other legends he is said to have taken the form of a bull, a shower of gold or, as here, a swan, in order to have his way. The consequences were significant since one of Leda's children by Zeus was Helen of Troy, whose abduction by Paris was said to have started the great Trojan War in which Agamemnon, Achilles, Hector and other heroes took part. The subject is a curious one for Leonardo to have chosen, since he generally showed a remarkable indifference to the literary and mythological side of classical culture, as well as ignoring women as sexual objects. But then his treatment of the story is decidedly unclassical, and shot through with some hard-to-decipher emotional ambiguity – or so it seems if we can rely upon copies, and in particular Cesare da Sesto's which is generally reckoned to be the closest to Leonardo's original. Both Leda and the swan are fairly extreme examples of Leonardo's taste for twisting or serpentine figures. Leda is a modest yet voluptuous nude who embraces her mate while he puts his wing protectively about her; in one corner of the painting four children have just broken out of two large eggs. As well as the expected background of rock, water and mist, there is an abundance of plants and fruit. Perhaps, if the picture is 'about' anything, it is about the processes of generation and birth.

The copies of the *Leda and the Swan* (there may have been a rather different version that never got beyond a cartoon) were all made by Milanese artists, so the painting was probably done after Leonardo renewed his contacts with the city in which he had served Lodovico for so long.

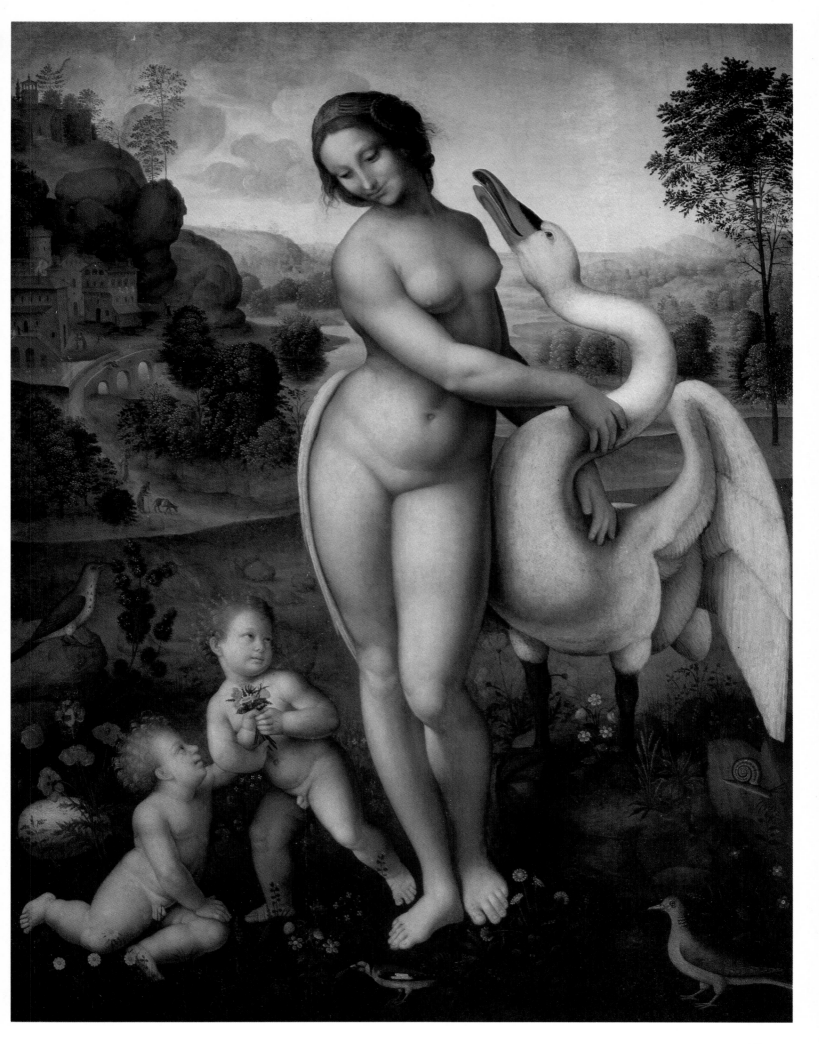

THE RESTLESS YEARS

We have seen that Leonardo displayed little in the way of political loyalty and, for that matter, was not expected to feel much. He was certainly not hostile to the French conquerors of Milan, except in so far as they made difficulties about returning the vineyard Lodovico had given him. He was evidently anxious to go back, but he was now so famous that he became the object of a tug-of-war, with the French eagerly trying to secure him while the Florentines strove desperately to make him remain in the city of his birth. Since the *Battle of Anghiari* was still unfinished, the Florentines had good reason (and a good excuse) for their unwillingness to part with him. On the other hand, the King of France was the most powerful ruler in Europe, and now a dangerous neighbour in Milan; the Florentines were not subservient, but it was evidently in their interests to be obliging. And so in May 1506 Leonard was granted three months' leave to work for Charles d'Amboise, the French governor of Milan. Later Charles wrote in the politest terms to the Signoria, requesting a month's extension. When this too had elapsed, the Signoria sent an angry note complaining that Leonardo had still not returned. They were discreet enough to blame the artist rather than the French lord of Milan; Leonardo was denounced for having

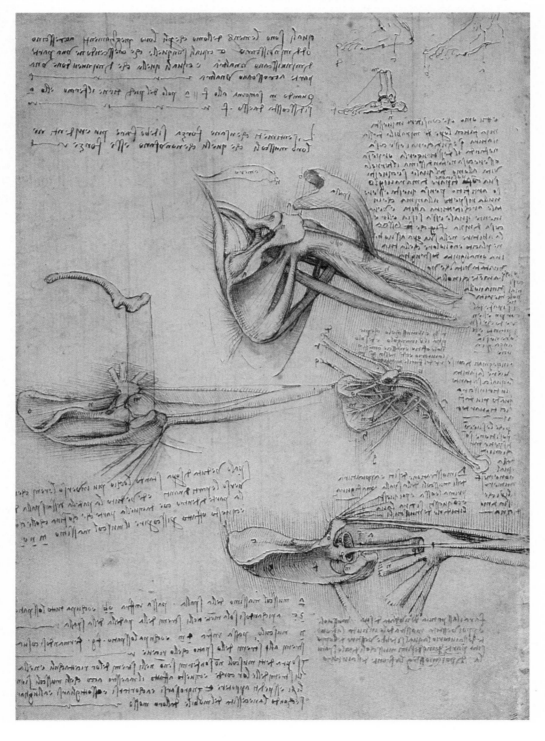

Studies of the bones and musculature of the shoulder. 1510–13. There are also three small studies of the foot and ankle in the top right-hand corner. Royal Library, Windsor Castle.

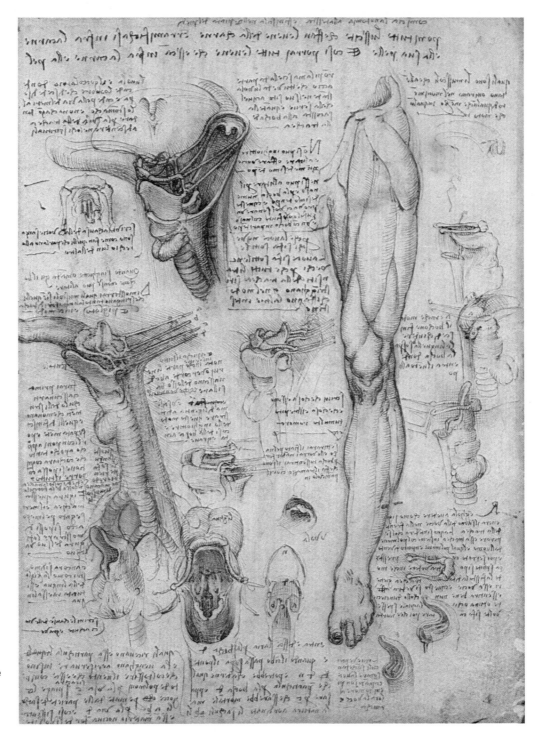

Studies of leg muscles, and of the mouth, throat and associated organs. Royal Library, Windsor Castle.

accepted their money and then failed to deliver the goods, but even so, Leonardo did not hurry back. Meanwhile the French king himself, Louis XII, intervened by putting pressure on the Florentine ambassador; at last, in January 1507, the Signoria gave way and agreed that Leonardo should be allowed to enter the King's service. He was to receive a 'pension' (which might better be described as a regular retainer – except that in practice the payments were anything but regular) and in April 1507 his Milanese vineyard was returned to him.

Exactly what Leonardo had done for his new masters up to this point is not known; perhaps they were already content to possess a cultural ornament without making too many demands on an ageing and notoriously erratic genius. But Leonardo's gifts as an organizer and designer of festivities were probably brought into play when Louis XII made a formal entry into Milan in May 1507. According to Vasari, Leonardo constructed an ingenious automaton in the form of a lion that took a few steps towards the king before its chest opened up to reveal clusters of fleurs-de-lis, the royal lilies of France. Other sources credit him with organizing the entire procession in which all who took part wore ancient Roman dress, and Louis passed in a chariot under an elaborately decorated triumphal arch. But more important from our point of view is the fact

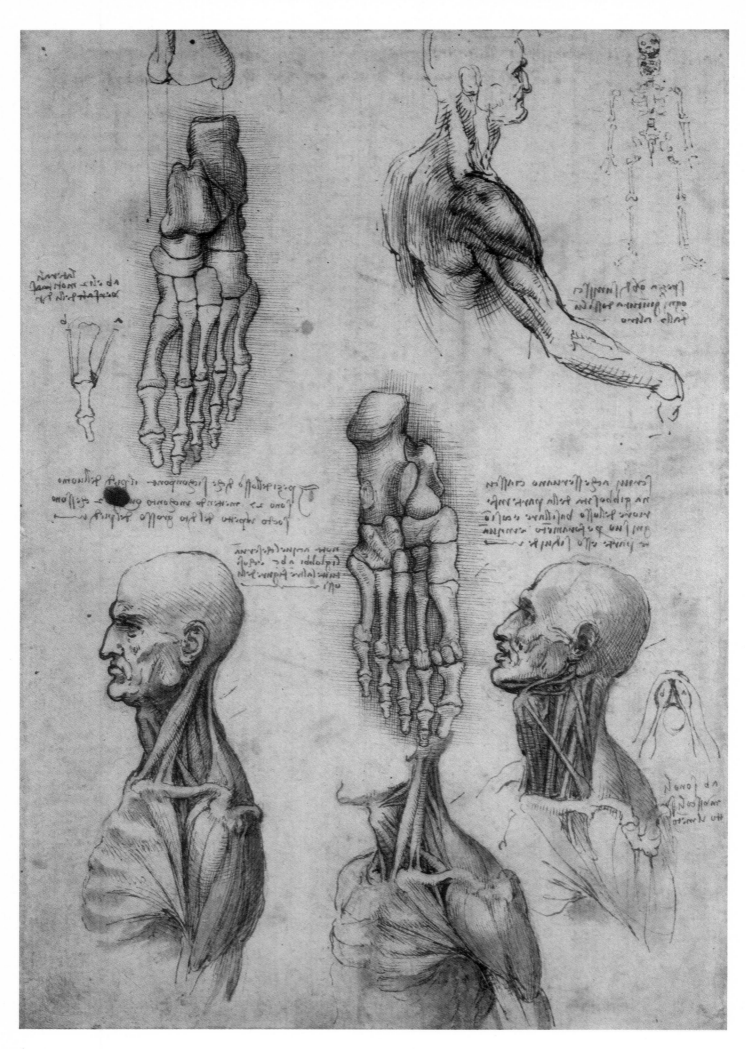

that during this period Leonardo finally came to terms with the Confraternity of the Immaculate Conception and began the final phase of the London *Virgin of the Rocks*.

However, Leonardo spent much of 1507–8 in Florence despite his new employment. He was delayed by a legal battle with his step-brothers over his uncle's will; then, as now, not to be present in court was to risk letting the case go by default. Leonardo pulled every possible string to have the issue decided quickly and in his favour; he even managed to have a letter sent in the name of Louis XII to the Signoria. But the law's delays were not to be circumvented, and it was spring 1508 before Leonardo was ready to return to Milan. In the meantime he lived at the house of a young sculptor, Gian Francesco Rustici, who refused to show his works in progress to anyone but Leonardo. Rustici's figures of St. John the Baptist, a Pharisee and a Levite, made for the north portal of the Baptistery at Florence, are – not unexpectedly – very much in the manner of his older friend.

All the same, Leonardo was delighted to get back to Milan. We can be sure of that because one of the letters he wrote to Charles d'Amboise from Florence has survived; it is an anxious letter, in which Leonardo wonders why his

Left:
Studies of foot bones and of neck musculature. Royal Library, Windsor Castle.

Studies of foot and ankle bones. Royal Library, Windsor Castle.

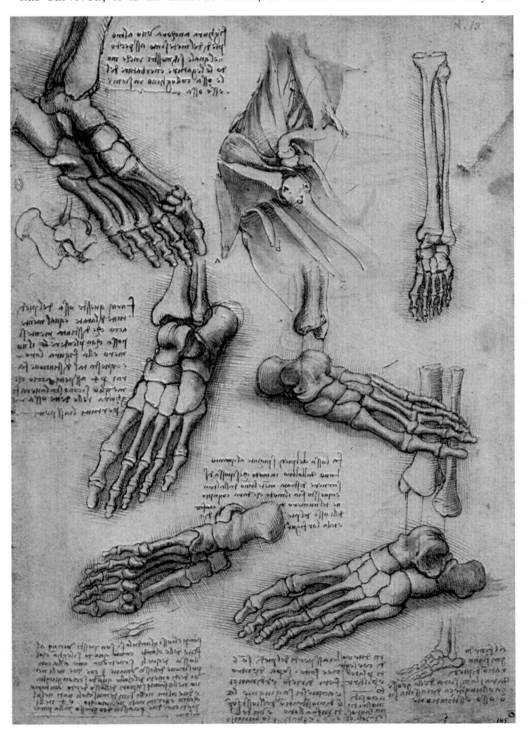

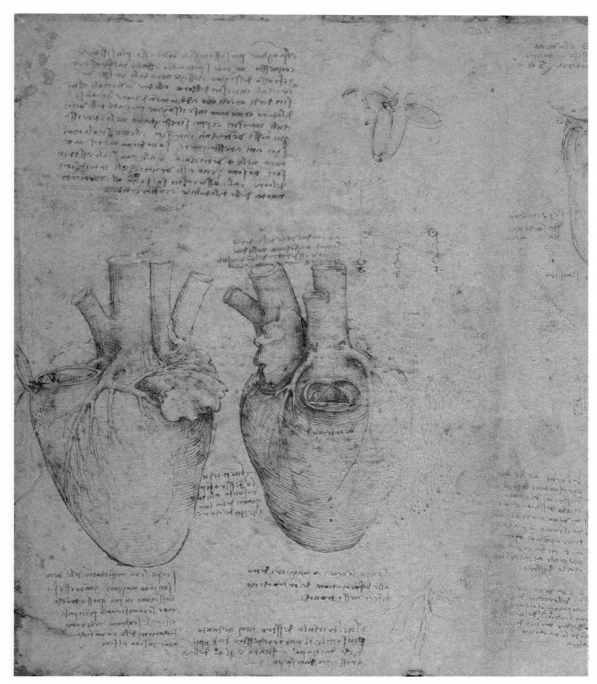

Studies of the
human heart. 1513.
Royal Library,
Windsor Castle.

previous communications have not been answered, apologizes for having done
so little for the King, assures Charles that his law-suit is almost decided,
promises to bring two Madonnas with him when he returns to Milan, and . . .
would like to know whether he is still to receive his pension. The answer must
have been satisfactory. Milan was to be his home again from 1508 to 1513, and
as 'painter and engineer in ordinary' to the King of France he must have been
a person of some consequence. But only one painting by Leonardo seems to
belong to this period, the *Virgin and Child with St. Anne*, a variation on a subject
we have already met in the National Gallery cartoon. Here, instead of blessing
St. John, the infant Jesus has grasped a lamb, while Mary, seated on her
mother's lap, reaches forward to take hold of her son. The original conception
may have involved an attempt by Mary, as a loving mother, to restrain Jesus
from embracing the destiny embodied in the Lamb, for centuries a symbol of
the Passion and the sacrifice it entailed. But in this version the atmosphere
seems too tranquil and harmonious (and Jesus too naughtily intent on mounting
the lamb) to bear such an interpretation except as a literary afterthought. If
tension and drama are present, they are to be found in the extraordinary com-
position, which has Mary sitting and bending forward to create a strong double
diagonal at the focal point of the painting. The angles and parallels arising out
of the mannered disposition of the bodies and limbs, the twisted postures, and
the flow and counter-flow of the draperies create an effect of restless movement

Anatomical drawing
of the female torso.
c. 1510. Royal
Library, Windsor
Castle.

62

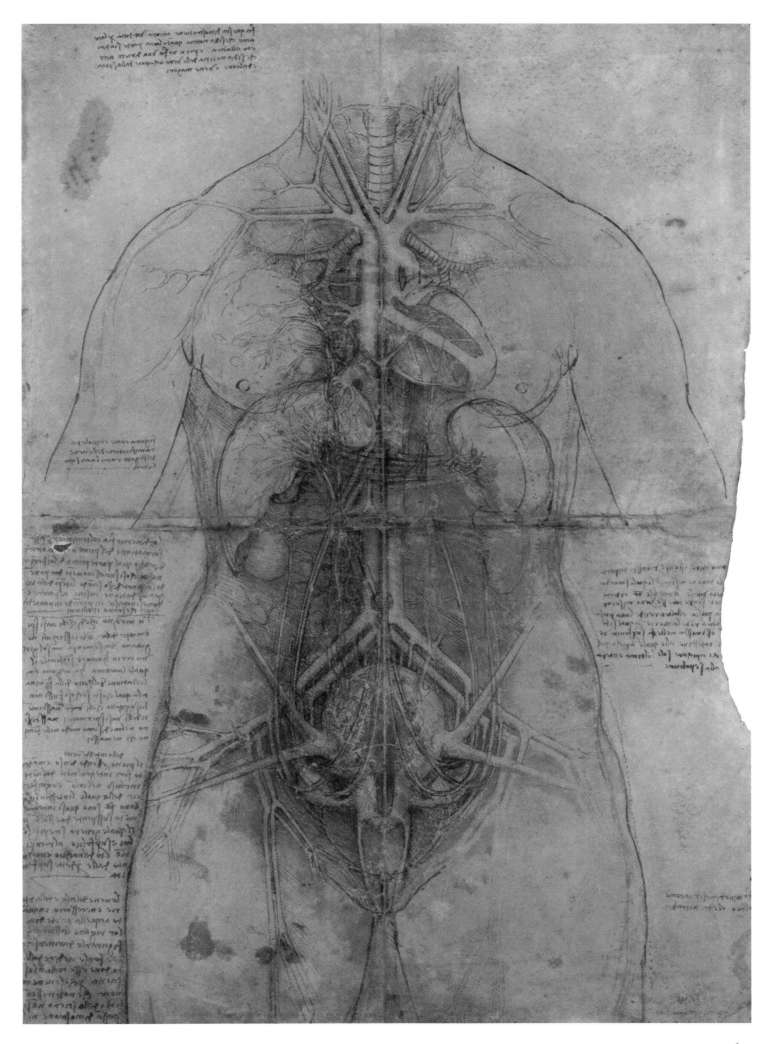

that was unique at a time when a classical monumentality had become the norm; there could scarcely be a greater contrast than that between Leonardo's painting and a Madonna by Raphael. In many respects Leonardo here anticipated the swirling, flamboyantly dramatic Baroque style of 150 years later. Which is not to say that the work is entirely a success. The heads are, for Leonardo, rather conventional and uninspired; and while the central group is a virtuoso achievement, it is not quite convincing either emotionally or anatomically. *The Virgin and Child with St. Anne* should perhaps be regarded as one of the most fascinating failures in the history of painting.

If the years in Milan were not rich in artistic achievement, the notebooks show that Leonardo was studying harder than ever, as though determined to solve the riddles of nature before he was overtaken by old age and death. In Florence he had worked intensely on anatomy, dissecting late into the night and recording his findings in superb, accurate drawings made from numerous points of view in the interest of scientific exhaustiveness. This was easily his most valuable and original contribution to science, and he dreamed of publishing his findings in a huge work consisting of 120 books. Instead he went on writing, drawing and experimenting, tackled geometrical problems, worked his way

Head of St. Anne. 1508–10. A study for *The Virgin and Child with St. Anne*, in black chalk on white paper. Royal Library, Windsor Castle.

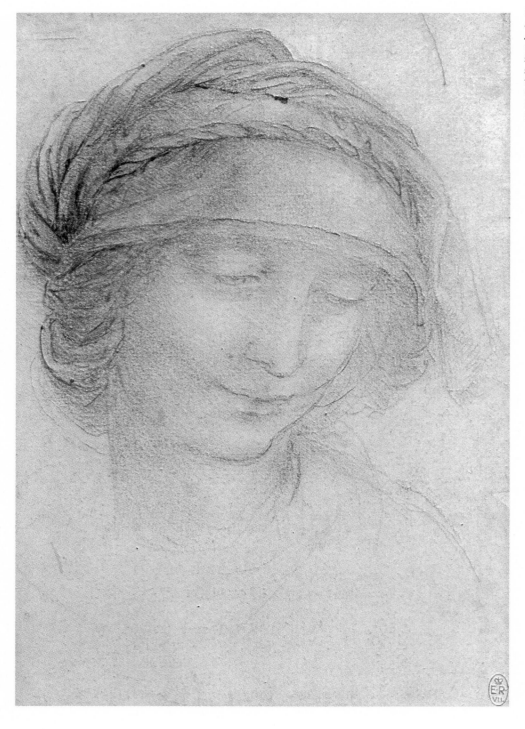

Right: *The Virgin and Child with St. Anne.* 1508–10. A painting on the same curious subject as the famous National Gallery Cartoon. Musée du Louvre, Paris.

64

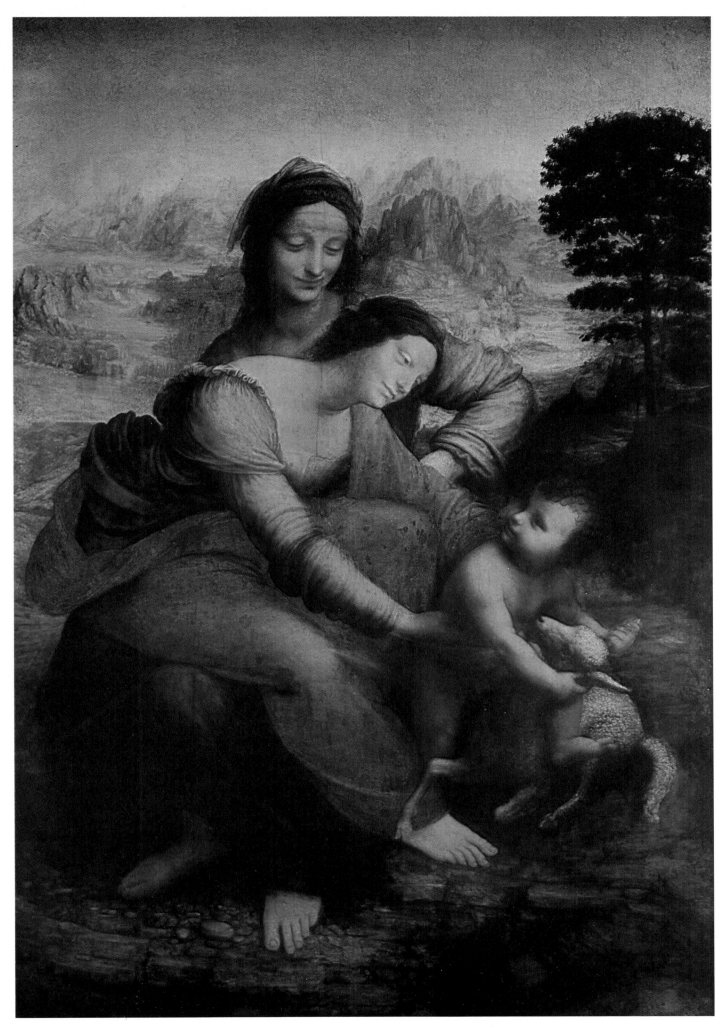

through Archimedes, did more dissections, studied the anatomy of animals and planned a long treatise on water. He was never able to face the uncreative labour of collecting and ordering his vast materials for publication; and so they remained unfinished and largely unknown for centuries. The sole exception was a set of designs and geometrical figures that Leonardo had made for his friend, the mathematician Fra Luca Pacioli, when both had been in attendance at the court of Lodovico Sforza; in 1509 Pacioli published them as illustrations to his book *De Divina Proportione*.

Leonardo's projected works for his French masters seem to have met with their usual fate. He planned an elaborate pleasure-house, full of mechanical contrivances, for Charles d'Amboise, but it was never built. And later, at the request of Charles's successor, Marshal Trivulzio, he drew up estimates for a tomb of epic scale and pretensions; it was to include an equestrian statue of the Marshal that should rival the destroyed Sforza 'Horse', and Leonardo himself was to sculpt a second figure of the Marshal in death, as well as the architectural details of the tomb. In view of the political situation, Trivulzio's intention can only be put down to senile megalomania, and Leonardo was perhaps only indulging himself in an amusing fantasy when he drew horses for the tomb and compiled estimates. In Europe, a powerful anti-French coalition (the Holy Roman Empire, the Pope, Venice, Spain, England and the Swiss cantons) had been formed, and when its forces marched on Milan in the spring of 1512, Trivulzio found it impossible to offer significant resistance. He fled, the city fell, and eventually Massimiliano Sforza, the son of Lodovico, was installed as the

Raphael. *Pope Leo X and Cardinals*. 1518–19. Leo was a Medici, and a lover of pleasure and of the arts, but he seems to have had a low opinion of his fellow-Florentine, Leonardo. Galleria degli Uffizi, Florence.

Sandro Botticelli. *Portrait of Giuliano de' Medici, c.* 1475. Botticelli was a mere six or seven years older than Leonardo, but his charming linear style is much more 'old-fashioned', belonging to the 15th-century Florentine tradition. Giuliano de' Medici was the younger brother of Lorenzo the Magnificent, with whom he ruled Florence until his assassination by the Pazzi. Crespi Collection, Milan.

new duke. Leonardo evidently felt in no danger from Massimiliano, despite his earlier 'desertion' of Lodovico. But once the apparent stability brought by French rule had disappeared, Milan offered no prospect of enduring quiet and security for creative or scientific work.

The appearance of a new patron at this moment must have seemed heaven-sent – literally so, perhaps, since the patron was a newly-elected Florentine pope. Giovanni de' Medici, one of the great Lorenzo's sons, assumed the name Leo X and at once declared, 'Since God has given us the papacy, let us enjoy it!' which was one of his more convincingly heartfelt expressions of piety. Leo loved pleasure, pomp and luxury; and he also loved art in so far as it glorified and pleasured him. He was a bad pope, but a generous patron to the artists of whom he approved. Taken directly under the wing of Leo's younger brother Giuliano, Leonardo must have believed that great things lay in store.

'I left Milan for Rome on the 24th day of September 1513, with Giovanni Francesco de' Melzi, Salai, Lorenzo and Il Fanoia,' he noted, as usual without adding a word about his feelings on the subject. Francesco de' Melzi, who heads the list, was the son of a Lombard landowner who had often entertained

Leonardo on his estate at Vaprio, some thirty kilometres from Milan. In 1508, when Francesco was fourteen or fifteen, Leonardo formally engaged him as his apprentice. They became devoted to each other, and the boy remained with Leonardo until his death, inheriting all the master's books and manuscripts. Nothing is known of Lorenzo and Il Fanoia.

In Rome, Leonardo was at first luxuriously accommodated at the Vatican, in quarters specially prepared for him on the orders of Giuliano de' Medici. But after this promising beginning everything went wrong. In art it appeared that Leo X preferred the clear classical style of a prolific young master from Urbino, Raphael Sanzio, to the more inscrutable (and less promptly delivered) creations of Leonardo. And when Leonardo did receive a painting commission, and laboriously began to prepare the varnish for it, Leo remarked disgustedly, 'This man will never do anything, for he starts by thinking about the end before the work is begun.' The remark sounds boorish and philistine, but no doubt the Pope was aware of Leonardo's reputation for unreliability and, with Raphael, Michelangelo and a host of other talented men ready to do his bidding, saw no reason why he should put up with any nonsense from Leonardo. For his part, Leonardo cannot have found the Roman atmosphere of intense rivalry and intrigue congenial, and he soon became (or believed he had become) the victim of some uncooperative German assistants who started a whispering campaign against him. Misfortunes multiplied: Giuliano de' Medici seems to have lost interest in his protégé and eventually left Rome; the Pope forbade Leonardo to practise dissection; and the artist fell ill. He was called in to advise on the draining of the Pontine Marshes south-east of Rome, a project that had been repeatedly attempted since antiquity; nothing was done about Leonardo's recommendations, and the marshes remained in existence until the 1930s. Altogether it was a frustrating period for Leonardo, and he seems to have got away from Rome as often as he could, making long trips to Parma, Milan and his native Florence.

Leonardo's 'outlandish experiments' in Rome may have been a reaction to frustration, or it may be that his eccentricities seemed more noticeable (and were less favourably noticed) in a hostile environment. He is said to have made a pet of a lizard, fixing wings made of other lizards' scales onto its back, keeping the miniature 'monster' to scare his friends. He used bellows to inflate bullocks' lungs to such a gigantic size that they crowded the occupants of a room into the corners. And on occasion he made some sort of wax paste that he could mould into animal shapes and blow up like balloons; when released, they flew about furiously until the air inside them was expended.

Tension and illness may have prompted works in quite a different vein. Leonardo executed a famous series of 'Deluge' drawings which are usually dated

'Deluge' drawing. c. 1514. Leonardo's obsession with this subject dates from his frustrating years in Rome, but this hardly seems to account for such a terrifying vision of universal annihilation. Royal Library, Windsor Castle.

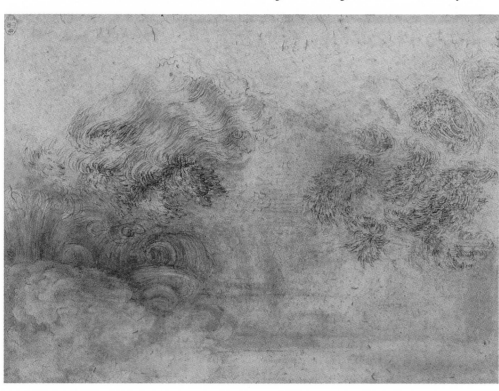

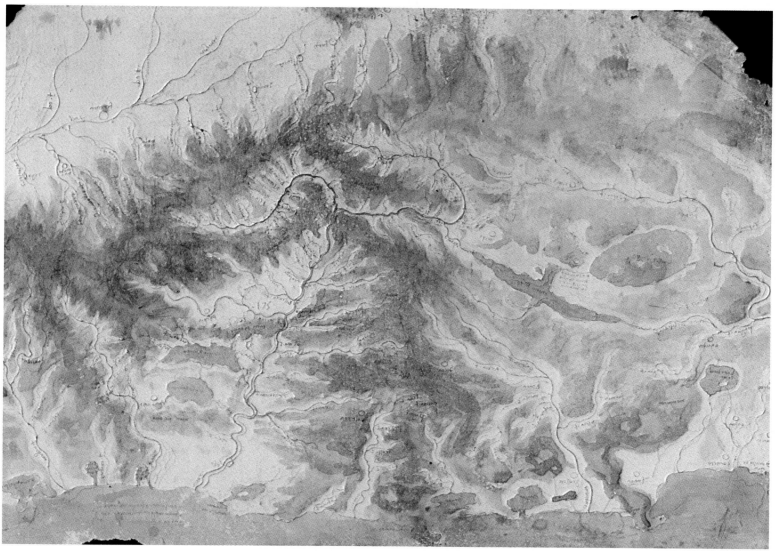

Map of Northern
Italy. 1502–3. This
is the finest example
of Leonardo's
meticulous map-
making, showing
the western coast
and the chief river-
systems of northern
Italy. Royal Library,
Windsor Castle.

to these Roman years. Water had always fascinated him, and he studied and
drew it from almost every imaginable point of view, accumulating quantities of
material which at one time he made a start on conveying into a treatise. Often
his drawings of water (and, for that matter, of fire and storm) reveal the
emotional involvement lurking behind his scientific preoccupation. But in the
Deluge series the reverse is true. In these, Leonardo occasionally takes a scien-
tific stance, as if reluctant to admit that his drawings are visions rather than
simple observations. Yet they *are* visions of a peculiarly terrifying nature, for
they prophesy a universal annihilation; the living mass of the waters is so
overwhelming that we only glimpse the mountains that are being swept away
and the debris of man's puny civilization.

The last paintings by Leonardo to have survived are two obviously related
works, the *Bacchus* and the *St. John the Baptist*; both are now in the Musée du
Louvre, Paris, and both were probably executed during Leonardo's unhappy
years in Rome. Bacchus is a young man sitting in a landscape with his legs
crossed and pointing to his left; St. John is smiling mysteriously and pointing
heavenwards. Although modern critics have praised the St. John in particular,
few people have ever really cared for either of the pictures, with their am-
bivalently coy, fleshy young men pointing this way and that. And neither seems
a convincing image of Bacchus, ancient god of wine and frenzy, or the ascetic
St. John the Baptist, the forerunner of Jesus; while the near-identity of the two
images, pagan and Biblical, has been another source of puzzlement.

Not all of this was Leonardo's doing, however. *Bacchus* is simply a disguised
St. John the Baptist, on whom leopard skin, vine leaves and other items were
painted at some time in the 17th century; a catalogue of the French royal
collection at Fontainebleau gives the title as '*St. John in the Desert*', which has
been struck through and amended to '*Bacchus in a Landscape*'. Even so, this
Bacchus/St. John may not be Leonardo's work. The conception is his, as we
know from a closely similar drawing among his papers, but the painting is so

inferior that it is often attributed to Cesare da Sesto or some other assistant of Leonardo's. In the drawing (stolen a few years ago from a museum at Varese, and therefore possibly destroyed), St. John is an attractively relaxed figure, whereas 'Bacchus' is at once over-fleshed and uncomfortably stiff. The problem of appropriateness remains. An Italian visitor to Fontainebleau expressed it simply when he remarked that the painting did not please because it did not arouse feelings of devotion.

The same objection can be made to the *St. John the Baptist* pointing heavenwards, though this is without doubt an authentic Leonardo. The faintly distinguishable cross he holds to his breast argues that the figure is indeed St. John. Yet the smiling youth and pointing finger also relate directly to at least one 'angel' drawing made earlier by Leonardo, and the painting would certainly be more comprehensible as the record of an encounter with a message-bearing angel. Then why did Leonardo change the subject to St. John? Nobody has put forward a really satisfactory explanation. Whether angel or saint, the young man evidently had a deep personal meaning for Leonardo and, given the uncharacteristically dark background from which the figure emerges, it is tempting to interpret him as the Angel of Death, come to call Leonardo to him and tantalizing the master to the end with intimations of the questionable and mysterious nature of things.

However he was not to die yet, and certainly not in Rome. He may have left the city for good by 1515, or may have continued for a time the pattern of wandering away in disgust and returning in hope. But in 1516 he was able to finish with Rome for good; he found his last and most generous patron in the new king of France, Francis I, who summoned him to leave Italy altogether.

St. John the Baptist. 1514–5. Musée du Louvre, Paris.

Right: *Bacchus.* This painting was a 'John the Baptist' until the 17th century, when somebody painted in the vine leaves and other Greek-mythical accoutrements. It is probably a copy rather than an original Leonardo. Musée du Louvre, Paris.

THE FINAL YEARS

At this time Francis was a singularly glamorous figure. He had come to the throne at the beginning of 1515 as a young man of twenty. He was handsome (in a rather curious 'plastic' way, so distinctive that all his portraits show it), vigorous, a lover of the arts, and, initially, a successful warrior. Within a few months of his accession he had invaded Italy and re-established French rule in Milan; it is possible that Leonardo met him on this occasion and even organized his welcome. Francis was even more culture-hungry than his predecessor, and in 1515 'culture' meant the arts and ideas of Italy. Given his age, Leonardo was probably invited to France as a prestigious ornament, rather than an active artist, but he was followed over the years by a steady stream of younger Italians including the great sculptor-goldsmith Benvenuto Cellini and the painter Andrea del Sarto. Eventually, under the aegis of Italian masters, a distinctive school of decoration developed on French soil, at the royal palace of Fontainebleau. In most respects Francis' reign failed to live up to its early promise, but the King does deserve credit as the man who successfully imported the Renaissance into France.

Leonardo was treated, quite literally, in princely fashion. He was awarded the title 'first painter and engineer and architect to the King', and was settled in a substantial house (he himself called it a *palazzo*, a palace) in the Loire country. Here, at Cloux, he was only a few hundred metres from the royal palace at Amboise, and the two were even conveniently linked by a tunnel. Francis moved about his kingdom a good deal, but when he was at Amboise he often consulted Leonardo. If Cellini is to be believed (and he *was* a fellow-Italian, a fellow-artist and a romancer), the King declared that Leonardo was not just a great artist but

Below: Bugiardini. Portrait of Michelangelo. Museo Buonarroti, Florence.

Right: Portrait of an old man, traditionally supposed to be a portrait of Leonardo himself in old age. Palazzo Reale, Turin.

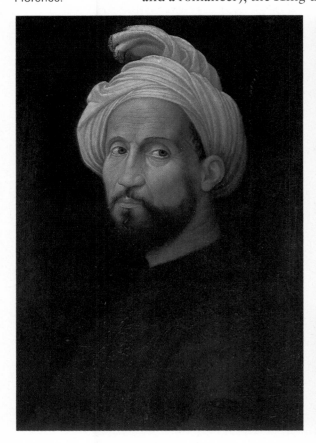

Right: Andrea del Sarto. *The Mystical Marriage of St. Catherine.* 1512. Gemäldegalerie, Dresden.

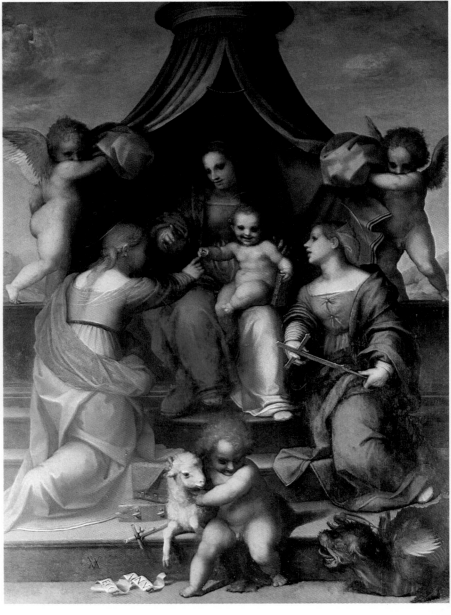

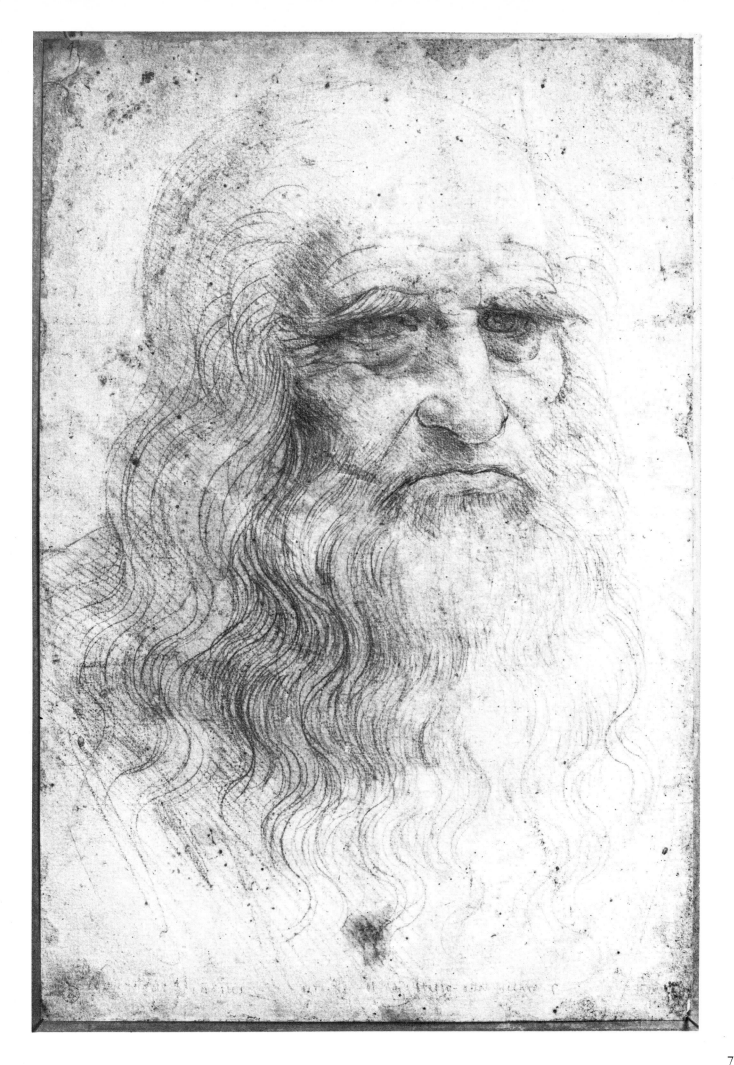

the wisest man who ever lived. However, few practical demands were made on the ageing Leonardo. He drew up plans for Francis' new royal palace and township at Romorantin, which was abandoned when hardly begun; and partly in connection with this scheme he returned to his old obsession, mapping ambitious river diversions and canal diggings that were never carried out. He may also have exercised his skill as a designer of pageants, though the only evidence is a mention of a (presumably clockwork) lion with the fleur-de-lis which Vasari says Leonardo made years before to welcome Louis XII to Milan; either the one mentioned in Francis' records was a duplicate or Vasari, writing decades later, mixed up the details – in which case the lion may not have been made by Leonardo at all. However, after the balloons and lizards that scandalized people at Rome, a mechanical lion would not come as a surprise as being an 'authentic Leonardo'. As his notebooks demonstrate, he was only sporadically active but by no means senile.

Actually Leonardo was not an old man; he was in early sixties, and might have gone on working to the last, like his younger contemporary Michelangelo, who survived to the age of eighty-nine. But tradition has it that Leonardo became prematurely aged, and a rather forbidding red chalk drawing of an old man, heavily lined and brooding, has been widely accepted as a self-portrait done before he reached the age of sixty. The tradition is confirmed by Antonio de Beatis, who met Leonardo on 10 October 1517 and took him for a man over seventy years old. De Beatis was secretary to Cardinal Luigi of Aragon, and left an interesting account of his master's visit to the artist that makes us wish we had more like it for the other phases of Leonardo's life. 'The most excellent painter of our time' showed the party three paintings, all 'most perfect': *St. John the Baptist*, *The Virgin and Child with St. Anne* and a portrait of a Florentine lady done (says de Beatis) for Giuliano de' Medici; this last must be a lost work, unless the generally accurate de Beatis has wrongly connected the *Mona Lisa* with Giuliano. The visitors were also shown Leonardo's great work on anatomy, with illustrations not only of the limbs but of muscles, nerves, veins, joints and intestines. De Beatis rightly remarked (perhaps echoing Leonardo's own words) that nobody had ever done anything like this before, and he noted admiringly that Leonardo claimed to have dissected more than thirty male and female corpses. His works on anatomy, hydraulics, machinery and other matters ('an infinite number of volumes') would, if published, be very profitable and enjoyable, concluded de Beatis with another of his rather stale adjectival formulas. As we might expect in a secretary, he thought it worth mentioning that Leonardo's scientific works were written in the vulgar tongue (that is, Italian), not in the universal language, Latin, which would have been employed by almost every other man of comparable attainments. De Beatis even noticed that Leonardo's right hand was partly paralysed – but, failing to observe his left-handedness, hastily inferred that no more first-class work could be expected from him.

Sound or not, de Beatis' inference proved correct; there were no more masterpieces to come. The paralysis may, of course, have been more serious than it appeared, perhaps resulting from a stroke. At any rate, Salai turned up in 1517 to look after Leonardo, who had at least two other servants in attendance, as well as Francesco de' Melzi and possibly other pupils who left no trace of their presence. Leonardo died on 2 May 1519 and was buried somewhere close to the royal chapel in the palace at Amboise, presumably on the orders of the King. According to Vasari, who liked a good story and rarely lost an opportunity to advertise the importance of the artistic professions, Leonardo died in Francis' arms after the King had shown him various signs of honour and consideration; but as it happens we can be sure that Francis was elsewhere, concerned with his newly born son. However, Leonardo's will laid down that his going should be of a kingly splendour – marked by nine high and ninety low masses celebrated in four different churches; by a procession of sixty paupers paid to carry tapers; and by a generous distribution of alms. In the will, Salai and the other servants were rewarded, and Leonardo's half-brothers received a sum of money, but Melzi was the main beneficiary. Leonardo was insistent that his friend and pupil should be regarded as his sole executor, and should inherit all his money, clothes, equipment, books and papers. His scientific reputation thus passed into Melzi's devoted but none-too-energetic custody; his art, despite loss and decay, had already made an unchallengeable place for itself in the world.

Portrait of a Young Lady. c. 1490. A pretty painting sometimes – dubiously – attributed to Leonardo. Biblioteca Ambrosiana, Milan.

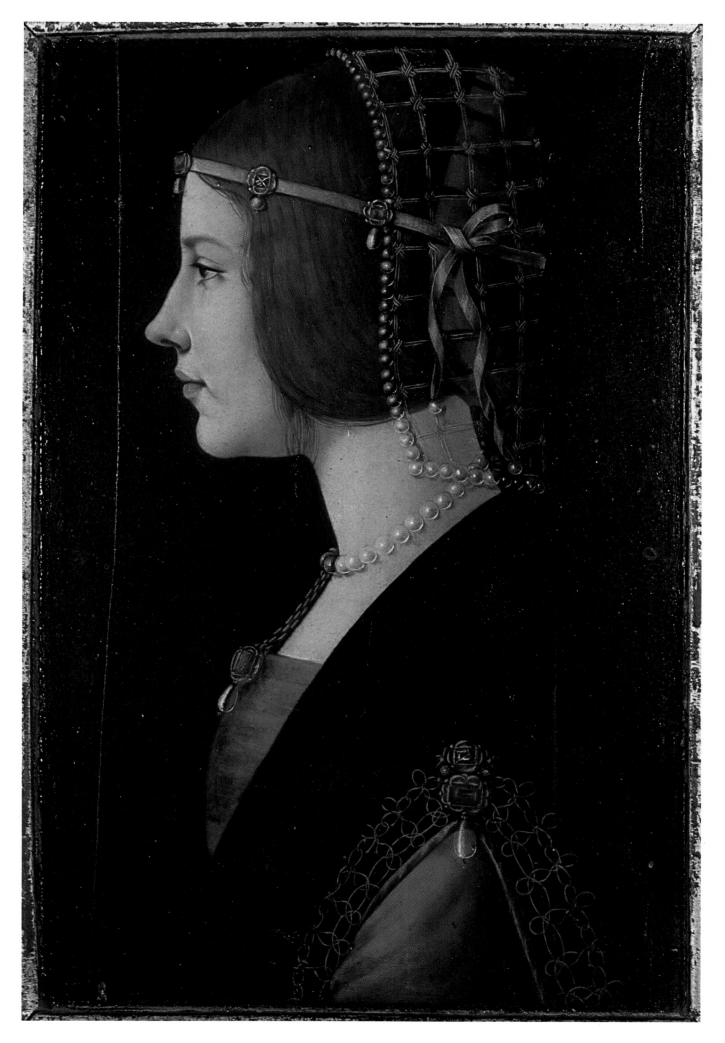

The Influence of Leonardo

Leonardo was a famous man during his lifetime, and his greatness was never seriously questioned in the centuries following his death. Yet his creations continued to suffer from the careless treatment and sheer bad luck that had so often attended his efforts. Some of the paintings were already deteriorating before Leonardo's death, and for this or other reasons many of them simply vanished without trace from the historical record at an early date; the 'Virgin and Child with a Yarn Winder', several paintings done during Leonardo's stay in Rome, and a number of others are no more than names to us. The drawings – those masterly productions in ink, chalk or silverpoint – were neglected and scattered for years before serious collecting began; but this is at least explicable in terms of Renaissance taste which, unlike ours, set little store by the sketch or fragment, regarding drawing as no more than a phase in preparing to execute a true, 'finished' work of art.

Leonardo's notebooks fared no better. Despite his good intentions he had failed to publish any of his laborious studies, but he must have hoped that his heir would undertake the task; Francesco de' Melzi was not short of money, was devoted to Leonardo and had no serious artistic ambitions of his own, as he showed by retiring to his estate at Vaprio after leaving France. There he stored the 10,000 pages of Leonardo's manuscripts in a special room; Vasari, who was allowed to look at some, says that Melzi watched over them as though they were religious relics. But his feelings of reverence did not prompt him to investigate the contents seriously, let alone prepare them for publication. The sole exception was Leonardo's mass of writings on the subject of painting, which Melzi made some effort to arrange in the form of a *Treatise on Painting*, though he flagged well before the end. Melzi's work, however half-hearted, may well have preserved this unique account of a great master's thoughts about his art. It was eventually published in the century following Melzi's death in 1570, after which all of Leonardo's original writings began to be scattered in a tragi-comic sequence of gifts, thefts and purchases. One 'connoisseur' whom scholars have damned ever since, the mediocre sculptor Pompeo Leoni, cut up many of Leonardo's pages in order to create a large decorative scrapbook by arranging designs and drawings in the order and pattern he fancied. Eventually Leonardo's notebooks were thoroughly dispersed over Europe, many disappeared entirely from view, and the full extent of his greatness continued to be unrealized. Only gradually, as items began to be acquired and analysed by permanent institutions such as the British royal collections at Windsor and the Ambrosian Library in Milan, did Leonardo's eminence as a 'universal man' become apparent. Even now, much of his work is missing and may never be seen again – though, as recent discoveries in Spain have shown, it is always possible that precious manuscripts, mis-catalogued, are gathering dust on library shelves somewhere in the world.

It should already be clear that a good many of Leonardo's paintings have also suffered through time and accident. But his *Mona Lisa* and several other masterpieces have been known from the first and have ensured a lasting influence for their creator. The least important manifestations of this influence were Leonardo's pupils and followers, such men as Cesare da Sesto, Bernardino Luini, Giovanni Paolo Lomazzo and Leonardo's beloved friend Francesco Melzi. None achieved real distinction; most were mere imitators who exaggerated characteristics of Leonardo's art – ambiguous smiles, a certain atmosphere of languor, dark melting tones – into mannerisms which they substituted for fineness of perception and execution.

At least part of the reason for this was that Leonardo exercised his most direct influence on the Milanese school, whereas it was Rome – which had rejected him – that attracted the most talented Italian artists in the wake of Michelangelo and Raphael. But in reality Leonardo's influence was all-pervasive. He was, as a later

76

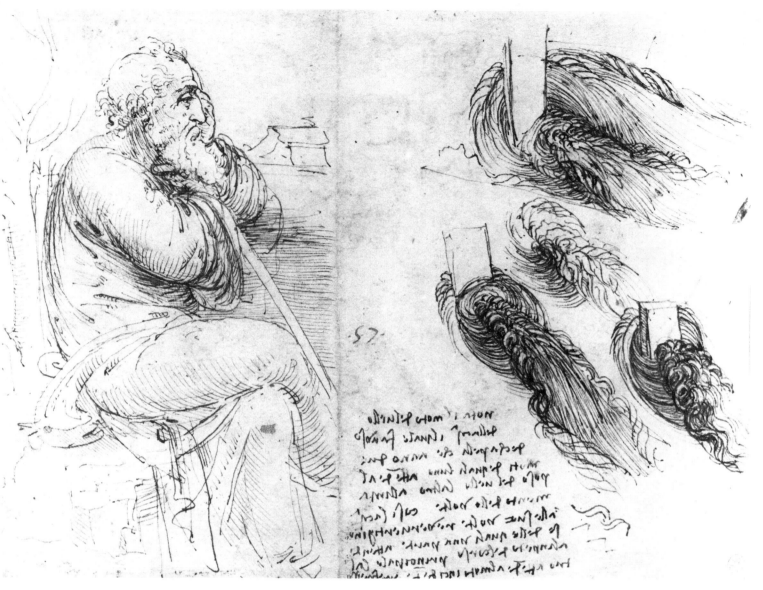

writer put it, 'the first father of painting' – or at least of Italian painting in oils, which was to become the chief painting medium for almost all of Europe's great masters. By contrast with older methods, oil painting was incredibly laborious but potentially far more subtle in its effects. The painter in oils proceeded by making a detailed drawing on his canvas, and then creating a virtually single-coloured painted base. Leonardo's *Adoration* and his *St. Jerome* were left unfinished at about this stage, just when subtleties of effect became possible. The artist went on to work with a range of colours, building them up in layer after layer so that very precise effects and gradual changes of tone could be achieved. The technique must have appealed immensely to Leonardo's patience and perfectionism – so much so that he tried to use oil-based pigments on his wall-painting, the *Last Supper*, hoping to better the broad effects of fresco and attaining a magnificent artistic success at the cost of technical disaster. But in his easel paintings, despite their yellowing varnish and even some deterioration, we can see that Leonardo had gone far beyond all previous painters.

Many of his innovations were in the general tradition of Renaissance naturalism. The posture of the Mona Lisa, for example, is not as simple as it seems and had never been attempted before, though Raphael and many others were quick to imitate it. But Leonardo's most profound contribution to European art was his use of *chiaroscuro*, effects of light and shadow, which we know he studied with scientific zeal. In his *Treatise* he states categorically that 'relief' – the illusion of three-dimensionality – is the essential quality in a painting; and it can only be achieved by capturing the play of light on a surface so that shadows and slight variations in tone indicate the recessions and projections of relief. Oil painting was the most suitable medium for such a task, as Leonardo triumphantly demonstrated. Imperceptible changes of tone (called *sfumato*) make a Leonardo face, or one of his melting landscapes, a creation of the light that falls

Left: Study of clasped hands. Drawing in black chalk for the hands of St. John in *The Last Supper.* Royal Library, Windsor Castle.

Right: Study of drapery. Musée Rennes.

Far right: Study of a sleeve. *c.* 1496. This drawing, in black chalk heightened with white, is a study for the arm of St. Peter in *The Last Supper.* Royal Library, Windsor Castle.

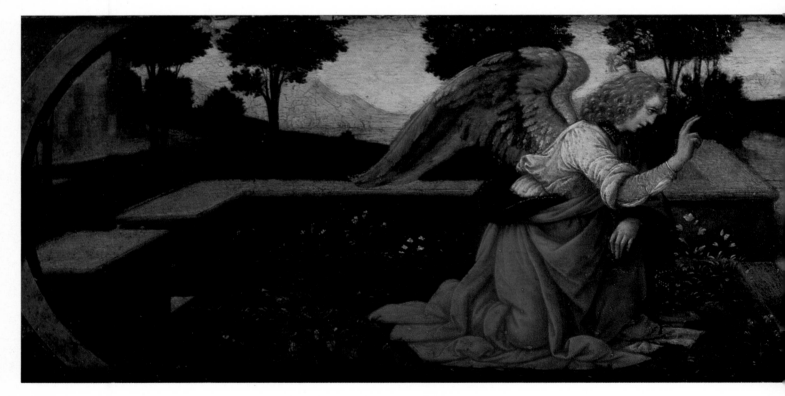

on it, exemplifying his belief that there should be no sharply defined contours in a painting. This was a radical departure from the style of most 15th-century Italian art (and especially Florentine art), which had if anything become more addicted to a linear technique and bright, decoratively used colours. If a head by, say, Botticelli is set beside one of Leonardo's, the extent to which Leonardo revolutionized painting becomes apparent at once.

There is also a change of mood and intention in Leonardo's work that had a more than individual significance. Leonardo, Michelangelo and Raphael are the three great masters of the High Renaissance which lasted from roughly 1500 to 1527. Each of them possessed a supremely assured virtuoso technique that enabled him to create any effect he wished (or so it seemed to contemporaries), and on one level the High Renaissance is simply a climactic display of such virtuosity. But the accompanying change of mood and intention is unmistakable

The Annunciation. An anonymous painting that has often, but probably wrongly, been attributed to Leonardo. Musée du Louvre, Paris.

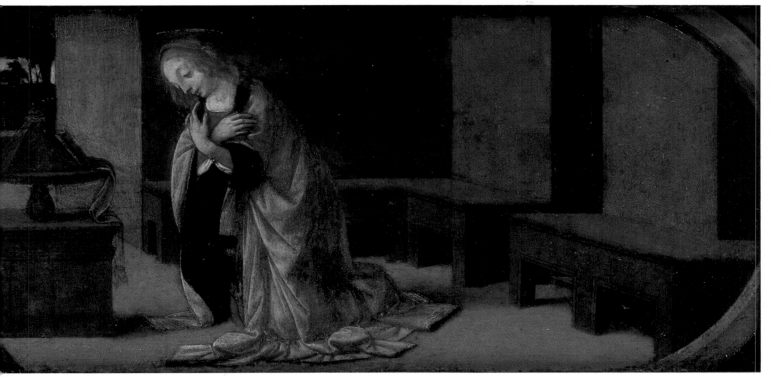

though difficult to define briefly – the greater solidity of forms stimulating a tendency towards conscious grandeur of effect, psychological intensity and ambitiously 'meaningful' schemes that expressed great ideas or spiritual conceptions. It was a more complicated mood than that of the 15th century, and the art to which it gave rise can sometimes seem less attractive than the straightforward, unpretentious works of the Early Renaissance. Its historical importance is undeniable, and its first exemplar was Leonardo da Vinci.

Finally, Leonardo, who had begun his career in the workaday atmosphere of Verrocchio's studio, became the first artist to be treated as an exceptional being, fit to walk with kings – another role in which he was to be followed by Michelangelo and Raphael.

His achievement, then, was threefold; he created great art, he influenced great artists, and he made men recognize the greatness of art and artists.

Acknowledgments

The illustrations on the following pages are reproduced by gracious permission of Her Majesty Queen Elizabeth II 19 top left, 31 bottom left, 31 top right, 31 bottom right, 33, 40 top left, 40 bottom left, 41 top, 41 bottom, 44 left, 44 right, 50, 51 left, 58, 59, 60, 61, 62, 63, 64, 68, 69, 77, 78 top left, 79 top left, 79 top right.

Alinari, Florence 34 top left, 73; Art Centrum-Neubert 24; Biblioteca Ambrosiana, Milan 39 left, 48, 75; Biblioteca Nacional, Madrid 38 left; British Museum, London 29, 31 top left, 32 left, 32 right; Christie Manson & Woods, London 8; Photographie Giraudon, Paris 7, 9, 26 right, 45, 54; Hamlyn Group Picture Library 10, 19 top right, 23, 34 bottom left, 40 right, 49, 51 right, 52, 56; National Gallery, London 35, 47; National Gallery of Art, Washington, D.C. 25, 26 left; Réunion des Musées Nationaux, Paris 55, 65, 70, 71, 78−79; Scala, Florence 6, 11, 12 left, 12 right, 13, 14, 15, 16 left, 16 right, 17, 18, 19 left, 20 top, 20−21, 21 top left, 21 top right, 22, 27, 28, 34 right, 37, 38 right, 39 right, 42, 43 top, 43 bottom, 46, 53 top, 53 bottom, 57, 66, 67.

Front cover: *Virgin of the Rocks.* 1506−8. Detail. National Gallery, London.

Back cover: *Virgin and Child with St. Anne and the infant St. John. c.* 1501. National Gallery, London.

Endpapers: Drawing of chariots armed with flails. *c.* 1495. Royal Library, Windsor Castle, *Marshall Collection.*

Title spread: Proportions of the human figure. Galleria dell' Accademia, Venice. *Fotografo Editore, Venice.*